The Campus History Series

MILES COLLEGE
THE FIRST HUNDRED YEARS

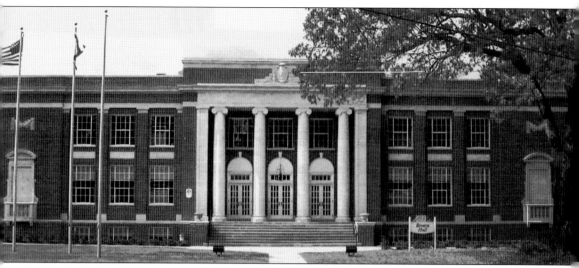

Built as the Administration Building in 1927, this structure was later renamed in honor of Bishop R. T. Brown. During the civil rights era, Brown Hall served as a haven for prominent civil rights leaders. Brown Hall was renovated in 2004–2005 for nearly $4 million and serves as the administrative center of Miles College.

The Campus History Series

MILES COLLEGE
THE FIRST HUNDRED YEARS

MILES COLLEGE CENTENNIAL HISTORY COMMITTEE

ARCADIA
PUBLISHING

Published by Arcadia Publishing
Charleston, South Carolina

Printed in the United States of America

Library of Congress Catalog Card Number: 2005925459

For all general information contact Arcadia Publishing at:
Telephone 843-853-2070
Fax 843-853-0044
E-mail sales@arcadiapublishing.com
For customer service and orders:
Toll-Free 1-888-313-2665

Visit us on the Internet at www.arcadiapublishing.com

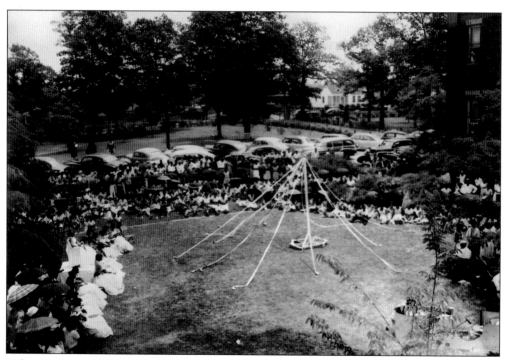

Miles Day—or "M Day"—is the college celebration to mark the end of the academic year. Pictured is a scene from the Miles Day celebration of 1949.

CONTENTS

PRESIDENT'S MESSAGE
A Sanctuary of Learning

With this history, I welcome you to be a witness to the extraordinary journey of Miles College—a story of struggle and sacrifice, success and opportunity. One book of history can only begin to tell our story.

For more than 100 years, Miles College has served as a sanctuary for learning. Created by the dedicated leadership of the Colored Methodist Episcopal Church, now the Christian Methodist Episcopal (CME) Church, Miles College sought to provide a learning center for African Americans at a time when educational opportunities were severely limited in the racially segregated South. Miles College survived the Great Depression and the war years, contributing to our nation's struggle through our students and alumni. The pages of this book tell that story and the stories of students who, as community activists, contributed to the civil rights movement as strategists, demonstrators, teachers, religious leaders, civil servants, and elected officials. As we continue to fulfill our founders' mission, Miles College alumni provide leadership for Alabama and the nation.

We offer thanks to those who have given so much to bring Miles College to where it is today. Our distinguished graduates are recognized as they bring the fruits of their learning to the world. Our honors scholars, debate team, sports teams, band, and choir carry our message beyond the state. We are educating more than 1,700 students in 22 accredited baccalaureate degree programs and strengthening our $12 million endowment to provide a secure future for the college. True to the vision of our forebears, we continue to serve our nation and sustain the African American community as a cultural center and sanctuary for learning.

My thanks to the Miles College Centennial History Committee and the Division of Social and Behavioral Sciences for the time and dedication they have given to the creation of this recollection of our journey. With great pleasure, I share with you our history and invite you to join with the students, alumni, faculty, staff, administrators, and friends of Miles College as we embark on our second century.

—Albert J. H. Sloan II

FOREWORD

The ancient Greek philosopher Epictetus once wrote, "First say to yourself what you would be; and then do what you have to do." The articulation and execution of a vision for the future have always been critical to personal and institutional advancement. During its first 100 years, Miles College has sought to define its own destiny and to identify a road map for realizing that destiny.

On a broader level, as a proud member of the community of Historically Black Colleges and Universities, Miles has always embraced the role of pluralism and diversity in its vision of higher education. Since the difficult days of segregation in Alabama, Miles College has stood as the beacon of hope for many who have been excluded by the public and private white institutions of higher education. It has instilled in its graduates respect for differing values, a sense of tolerance, and high ethical responsibilities. Embracing a variety of distinct "languages" of understanding, including "self-understanding" and educational democracy, the college has very successfully directed its collective energy to recruit, retain, and graduate many who could have missed a higher education.

Miles College's role in the larger Birmingham community and in the state and nation has never been static or linear. Dear old Miles has weathered racial, cultural, financial, and political storms, ranging from the days of Jim Crow laws and the Great Depression to the civil rights movement; from geographic relocation to the loss of accreditation and the triumph of reaccreditation. Change for the better has been the singular constant during its first 100 years and will undoubtedly be so for the next 100 years as well.

This mission of positive change for more than a century is being celebrated and chronicled for posterity in *Miles College: The First Hundred Years*, under the auspices of the Miles College Centennial History Committee and the Division of Social and Behavioral Sciences. We cannot fail to analyze the years of Miles's upheaval or ignore the warning of our own American philosopher, George Santayana, who said, "Those who cannot remember the past are condemned to repeat it."

The reader should note that this is a pictorial history in the sense that the authors have taken great care to identify the photographs relative to the college and comment on their historical significance. This book would not have come into being without the hard work and dedication of the Miles College Centennial History Committee, which included, among

7

others, the college's very fine institutional development director, Dr. George French, one of the four coauthors. The other three coauthors, who happen to be the historians on the faculty, are Drs. John Morgan, Gary Sprayberry, and Robert Woodrum. John Morgan's dedication to this project has made this book a reality. Dr. Beverly Hawk, a political scientist on the faculty, provided tireless editorial assistance. Ms. Barbara Nunn, an assistant professor of African-American history in the division, read a draft of the manuscript and offered insightful comments. I would also like to thank the secretary of the Division of Social and Behavioral Sciences, Ms. Frances Pryor, for her indefatigable assistance in producing this book.

It was a great honor for me to chair this hard-working and talented group of scholars. Dr. Robert Cassanello, University of Central Florida, a distinguished historian of the Deep South, who carried out the initial research of this history project during his tenure in the division, and Bishop Othal H. Lakey, an eminent historian of the Christian Methodist Episcopal Church, guided this project as consultants. Bishop Lawrence L. Reddick III, presiding bishop of the Fifth Episcopal District Christian Methodist Episcopal Church and chair of Miles College Board of Trustees, is to be recognized for his gracious encouragement and assistance regarding the early history of the college.

A special word of appreciation needs to be given for the help and encouragement of Albert J. H. Sloan II, president, and the Miles Centennial Planning Committee, at whose suggestion the study was undertaken. The authors and the committee are also indebted to Dr. Hattie G. Lamar, academic dean, for her support. Dr. Richard Arrington Jr. and Dr. Abraham L. Woods Jr. are two alumni and professors at Miles who made many helpful suggestions for the development of the study. We must also thank Dr. Geraldine Bell, the college librarian, for providing access to the Miles College Archives. The photographs used in this book are drawn from the Miles College Archives, the Christian Methodist Episcopal Church Archives, and Miles College yearbooks. We give thanks to all those who have donated photographs and memorabilia to the archives that we may record and preserve our legacy, particularly Cloud Studios, Hill's Studio, Brown's Studio, Morrow's Studio, Bennett and Hill, Curry Photo Service, and Chris McNair Studios.

Miles College is the instrument through which this pictorial was planned and the final book brought out in printed form. This historical research and chapter composition required hundreds of hours of work from our scholars. Their incisive analysis, eloquent presentation, and scholarly insight have given the college a wonderful gift on its 100th birthday. However, the materials presented and the opinions expressed are those of the authors and the committee, who accept full responsibility for them.

—Digambar Mishra, Chair
Division of Social and Behavioral Sciences
Miles College Centennial History Committee

INTRODUCTION
An Appreciation of Miles College

If excellence in the person is the full development of his human potential, how are we to judge excellence in the college? . . . [One way] would compare the level of development of entering freshmen with that of graduating seniors. By measuring change rather than absolute levels, this way would reveal how much the college has done, as distinct from whom it was able to recruit. . . . Instead of judging a college's success by who goes there and how well they are expected to do, I suggest that we focus on what happens at the college, on what kind of change it induces. For example, if a college admits students with relatively primitive tastes, shallow interests and rigid patterns of thinking, and if after four years it turns out students who are flexible, imaginative, discriminating and capable of self-expression, the college is undoubtedly a success—even if none of its teachers were ever heard of outside of its own locality and the level of accomplishment of its students at graduation were not as high as that found in better-known institutions.

—From *Where Colleges Fail* by Nevitt Sanford of Stanford University, Jossey-Bass, 1967

The above quote from Nevitt Sanford always brings to my mind the important role of the "special mission" fulfilled by Miles College and like colleges—that of taking on socially important and hitherto unmet responsibilities in our society. I understand this mission to be that of searching out the neglected and often under-performing students of urban and rural America's pockets of poverty and giving them the motivation, opportunity, and skills to contribute effectively to our highly competitive society. By doing so, it enriches their lives and our society as a whole. It infuses the often forgotten student with dreams and the confidence and skills to fulfill them. That is precisely what Miles College has done for me and many other students of similar socioeconomic circumstances. There were many such students in my 1951 Miles College freshman class, my 1955 Miles College graduating class, and many others in every Miles College class. Today, throughout our nation, Miles College graduates are filling highly responsible and challenging jobs. Indeed, they are listed among congressmen, top scientists, physicians, business people, and teachers. They have gone on to successfully complete programs of study at some of America's better-known graduate institutions.

The dreams of its founders—most a few generations removed from slavery and often unlettered—to build an institution that would give their children and grandchildren and their generations an opportunity for the education denied the founders, have become a reality. Their struggle against overwhelming odds produced a college that is 100 years old, vibrant, contributing, and growing.

Despite living in a rigid, racially segregated, and often cruel and repressive South, Miles College was able to inspire me to aspire for high achievement. That inspiration undergirded me during my successful journey through graduate school and public service in elected office in the state of my birth.

How alive have come the words that I often heard as a student in chapel at Miles College, from one of its presidents, Dr. W. A. Bell. He said of Miles College: "I love every blade of grass that grows on its campus." His words resonate with me today—and quietly I utter, "Me, too."

—Richard Arrington Jr.
Miles College Class of 1955

One

THE CHRISTIAN METHODIST EPISCOPAL CHURCH AND ITS EDUCATIONAL MISSION

The Historically Black College or University (HBCU) is one of the unique institutions to emerge from post–Civil War America and is one of its great success stories. Prior to the Civil War, there were a handful of northern primary and secondary schools to serve black educational needs. Post-secondary and university education were almost unobtainable, and only two educational institutions existed prior to the war. The post-war period saw the great need for an educational system geared to meet the requirements of recently freed slaves entering into the broader American economy and society. The establishment of the land grant universities did little to either allow black admittance to white institutions or to create new black ones. The only black public college in the South prior to 1890 was in Mississippi, for which the state had allocated land-grant funds.

The establishment of private institutions was the only way to make up for this lack of public black colleges, and several were founded in the latter third of the 19th century. Among the HBCUs founded in the late 19th and early 20th centuries were those of the Colored (later Christian) Methodist Episcopal (CME) Church, which was founded in 1870. The CME Church was at the forefront of service to the African American community, ministering to its spiritual and material needs. In 1866, the Annual General Conference of the Methodist Episcopal Church (South), aiming to best benefit the journey of the freedman into liberty and citizenship, summed up its ideal: "It is our purpose . . . to call a General Conference . . . for the purpose of organizing them into an entirely separate church, thus enabling them to become their own guide and governors." This message became the goal of the CME Church.

The church, in accordance with traditional Methodist doctrine, stated that the key to personal salvation lay in "Christian mission and service to the world," and that "love of God is always linked with love of neighbor, a passion for justice and renewal in the life of the world." The CME educational mission, in this tradition, was to provide the best opportunity

11

for freed slaves to overcome the inequalities imposed upon them. Education and religion were the same to the church and were characterized by the term, "Christian Education." The church actively sought to involve the white community in its educational enterprise in what became known as the "Paine Principle." It emphasized interracial cooperation as a foundation on which to convince Southern whites of their moral responsibility to educate and financially support former slaves.

One of the CME Church's first efforts was to disseminate its message through the printed word and education. To this end, the church founded its first publishing house in 1870 and began printing *The Christian Index*. The church also tried to establish Central University in 1874, headed by Bishop William H. Miles. Central University launched the CME Church into the field of higher education to train church ministry. This venture failed, due to financial and administrative difficulties, inducing the church to change its educational emphasis from seminaries to liberal arts colleges designed to educate the broad mass of the black community.

Despite the failure of Central University, the church persevered in its educational efforts and gathered support from local communities. In particular, the church solicited help from white subscribers nationally. By 1885, in cooperation with the Methodist Episcopal Church (South), the church founded Paine College in Augusta, Georgia. The next year, it founded a second institution, Lane College, in Jackson, Tennessee.

In 1893, the CME Conference of Louisiana established Homer College, based on Homer Seminary. This institution became the model of the small CME school that provided an education to rural blacks who were otherwise denied. This opportunity offered a broad range of programs including elementary, high school, college preparatory, and college programs. Homer College also provided community services that helped to form a tradition of community participation in all CME colleges throughout the 20th century.

By the mid-1880s, the CME Church was well established, expanding, and proceeding on its three-legged mission of education, black progress, and religious evangelism by establishing a variety of schools. The colleges provided an excellent education to students, as *The Christian Index* noted in a 1910 report on the success of Lane College: "At present, the school proposed to guide our young people in all of the advantages of a liberal education. Young people graduating from our course in liberal arts . . . take their places . . . with students from many of the best of our Southern schools." By the end of the 19th century, the CME Church would be ready to establish its sixth college, named after its leading bishop, William H. Miles.

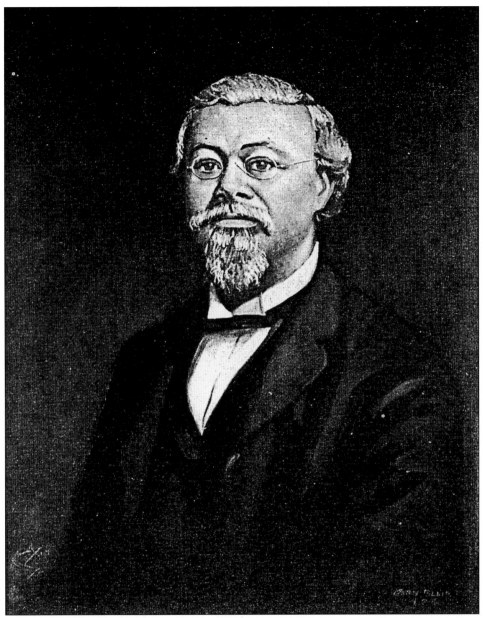

William H. Miles was born a slave in 1828 and freed in 1854. He joined the Methodist Episcopal Church (South) in 1855, and the church licensed him to preach in 1857. Following the Civil War, Miles joined the newly founded CME Church and established a conference in Hopkinsville, Kentucky. Elected a bishop in 1870, he organized conferences, established church institutions, and defined church theology. Over the next 22 years, he led a church that grew into one of the largest in the South. Miles saw the church as a source of spiritual solace for freed slaves and as the expression of black freedom and self-government. He believed that moral and civic virtue would help the people rise above the state of physical and spiritual bondage. He embraced traditional Methodism for its simple theology, practical piety, and ability to meet the spiritual needs of African Americans. Bishop Miles was a central figure in the CME Church until his death in 1892. Miles College is named in his honor.

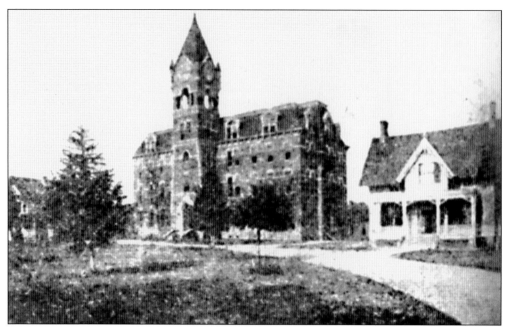

The first CME college, founded in 1885 in Augusta, Georgia, on the principle of cooperative effort between Southern whites of the Methodist Episcopal Church (South) and blacks of the CME Church, provided a broad curriculum of theology, normal, college preparatory, and college courses. It was the prototype of CME educational institutions and a model of interdenominational cooperation.

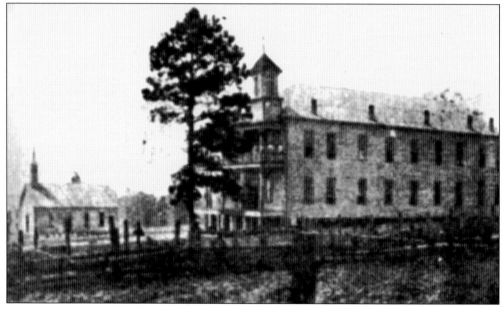

The CME Louisiana Conference founded Homer College in 1910, based on Homer Seminary. Homer College combined every level of education from primary through college. This was a model of comprehensive curriculum to meet the needs of a broad range of African American students, also providing vocational training in blacksmithing, military drill, millinery, and cooking. The college closed its doors in 1918.

Two

BEGINNINGS
1898–1918

Two rivers became one. In 1898, the CME Church, seeking to expand its educational curriculum across the state of Alabama and thus fulfill part of its "Christian mission," opened a high school in the city of Thomasville in Clarke County. Four years later, in 1902, the church acquired 10 acres of land east of Birmingham and began constructing another such facility to service the needs of African American students in the northern half of the state. The latter school was built in the recently incorporated township of Booker City (now called Docena). Although both institutions would operate independently of one another for a number of years, the eventual founding of Miles College could be considered a consolidation of the two schools.

Back in 1898, the same year that Thomasville High School was organized on the edge of the Black Belt, the two annual CME conferences of Alabama had discussed the possibility of establishing an institution of higher learning within the state to coincide with their recent foray into secondary education. By 1905, the idea had reached fruition. In that year, trustees from the two conferences submitted a petition to the state of Alabama, asking for permission to charter Booker City High School as Miles Memorial College. The state granted the charter, and the school began accepting students into its new program.

The discovery of coal near the site of the Booker City campus in 1907 prompted the Tennessee Coal, Iron, and Railroad Company (TCI) to negotiate a purchase of all the CME holdings in the vicinity—technically, the church owned the land, but not the mineral rights to the land. In exchange for the Booker City property, TCI agreed to hand over 30 acres of land in Fairfield and more than $30,000 to be used toward the construction of a new school. The site would become the permanent home for Miles.

By 1907, the original high school had evolved into a full-fledged college under the stewardship of James A. Bray, Miles's first president. While maintaining its primary and secondary students, the school began offering a variety of college-level courses as well, such as mathematics, rhetoric, literature, Greek, Latin, psychology, and history. Having been denied access to the state's other institutions of higher learning, the children of Birmingham's rising black middle-class and working-class communities began making their way to the Miles campus, seeking the same educational opportunities that white students enjoyed throughout Alabama and the rest of the South. They were not alone. At approximately the same time that Miles Memorial College opened its doors, the CME-sponsored high school in Thomasville closed, and the majority of its students transferred

to Miles. For years after, the CME Church would actively encourage the young men and women of Thomasville and the surrounding region to attend the new school in Fairfield. Two channels had finally converged into one steady stream.

The early years of Miles were arguably its leanest. Realizing that the $30,000 from TCI would only go so far, the school's trustees initiated a statewide campaign to raise additional funds. "Under the magnetic and dynamic leadership of Bishop Robert S. Williams," school representatives and boosters fanned out across Alabama, convincing thousands of men, women, and even children to contribute part of their decidedly meager incomes to the fledgling school. And because of their generosity and vision, the school's first and oldest building, Williams Hall, was completed in short order. A second building, added on the eve of World War I, doubled as an administrative facility and men's dormitory until fire destroyed it a few years later.

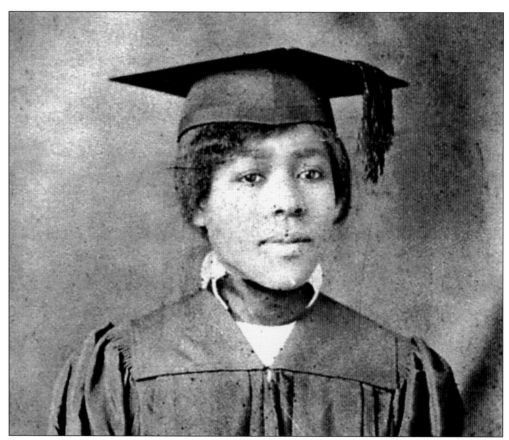

From the very beginning, Miles College was a coeducational facility. In fact, in the grammar school and "normal preparatory" sections of the institution, the overwhelming majority of the student body was female, according to the 1909–1910 catalogue. In May 1918, Mrs. Willie Selden McDaniel (pictured above) became the first woman to receive a bachelor's degree from Miles Memorial College. She, like scores of other female graduates from the college, became a teacher in the public school system following commencement. A talented musician, she was also an organist for various churches in the Birmingham area and for the Christian Industrial Social Club of Fairfield.

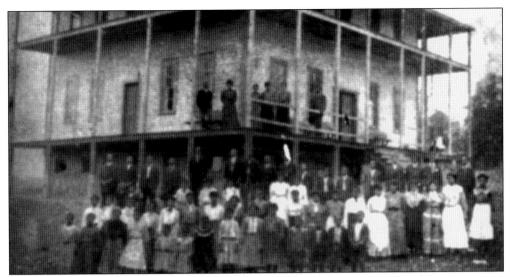

In 1902, the CME Church acquired 10 acres of land in Booker City, a recently incorporated township east of Birmingham, and established a high school (pictured here) to service the needs of African-American students in the northern half of the state. Booker City (now called Docena) was the brainchild of a white real-estate speculator named E. W. Whips, who envisioned the town as a veritable utopia where middle-class African Americans could open successful businesses and raise strong families away from the prying eyes of racist whites. The CME school would accordingly serve as the anchor for such a community. Whips named the town after Booker T. Washington, the founder and president of Tuskegee Institute, and hoped its citizens would adopt the famed educator's admonition to work hard, save money, and make themselves "indispensable" to whites. Although Booker City never quite lived up to Whips's grandiose vision, the CME-sponsored high school would later evolve into Miles Memorial College and find a new life in Fairfield.

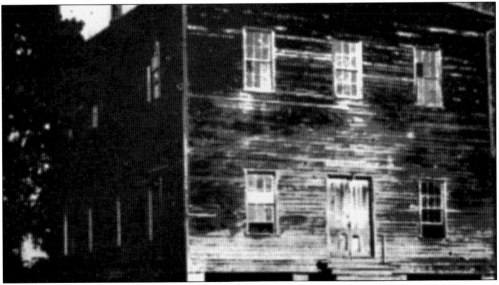

The CME Church began its educational work in Alabama at Thomasville, where it established the Thomasville High School. When the Thomasville High School closed its doors around 1907, students from the area were actively encouraged to enroll at Miles College.

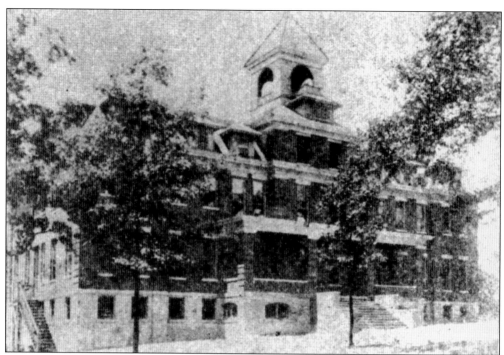

Williams Hall became the first college building completed on the campus in 1907 (above), though it was the second permanent structure. It was named after Bishop R. R. Williams, the presiding CME bishop in Alabama, who raised construction funds in part from TCI. It served as the old administration building, women's dormitory, and location for home economics classes. In 1937, the building was struck by lightning and damaged by fire. The college demolished the upper floor and central tower and rebuilt it to conform to the latest architectural design of the buildings on campus at a cost of $10,000. Williams Hall is pictured below as it has appeared since 1937. This photograph was taken in 1951.

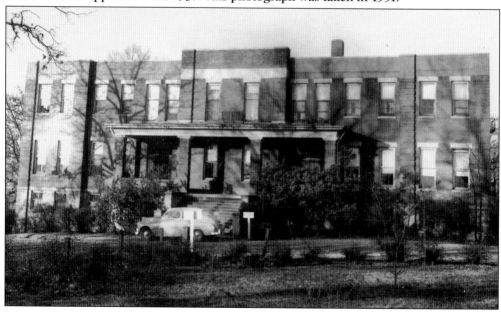

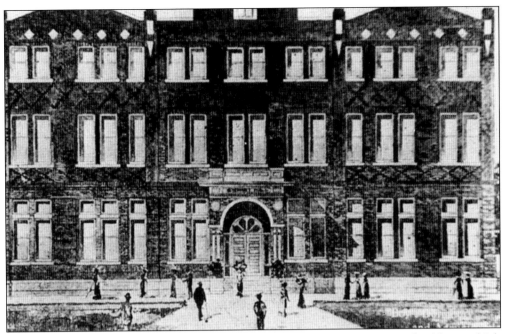

This is an artist's rendering of the boys' dormitory and administration building, which was completed around 1914. Fire gutted the building on two separate occasions. It was never rebuilt.

According to the 1917–1918 college catalogue, "Boys under 18 and girls under 17 years of age boarding in the college dorms are not eligible for any special social privileges. The social side of student life demands wise and discreet management."

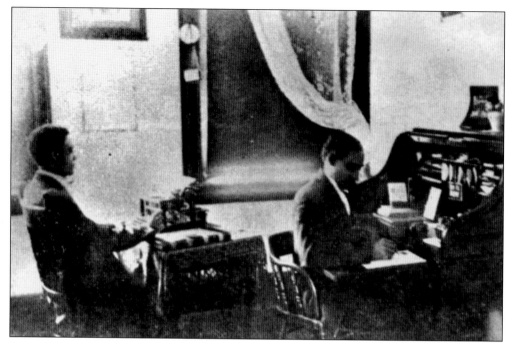

James A. Bray (right) served as the first president of Miles Memorial College, holding the office from 1907 to 1912. He is shown here working diligently at his desk in 1909. A small sign hanging in the middle of Bray's roll-top desk urges, "Do it now."

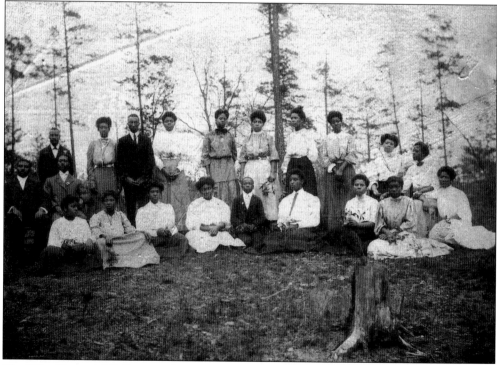

The Miles Memorial College student group pictured here in 1907 are among the first students to attend the college.

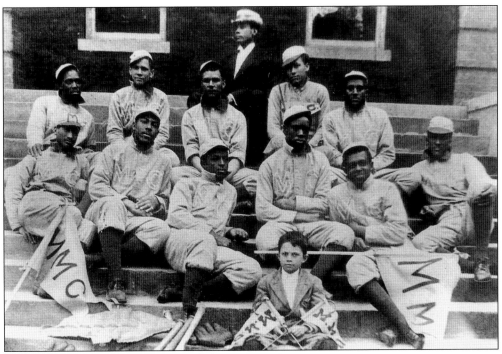

Miles Memorial College's baseball team is pictured in 1909.

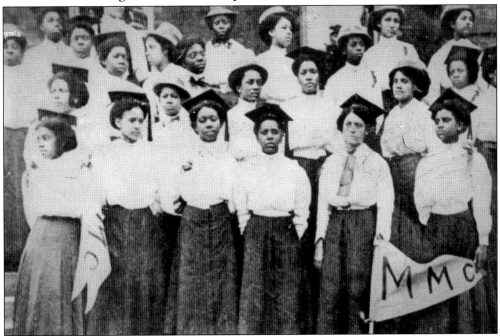

Miles has served as a haven for women's educational opportunities since its inception. In the academic year of 1909–1910, the college educated 139 female students (out of a total of 158 students) in the grammar, sub-normal, normal preparatory, and college preparatory classes. Women were housed in the women's dormitory in Williams Hall, which doubled as the home economics class building.

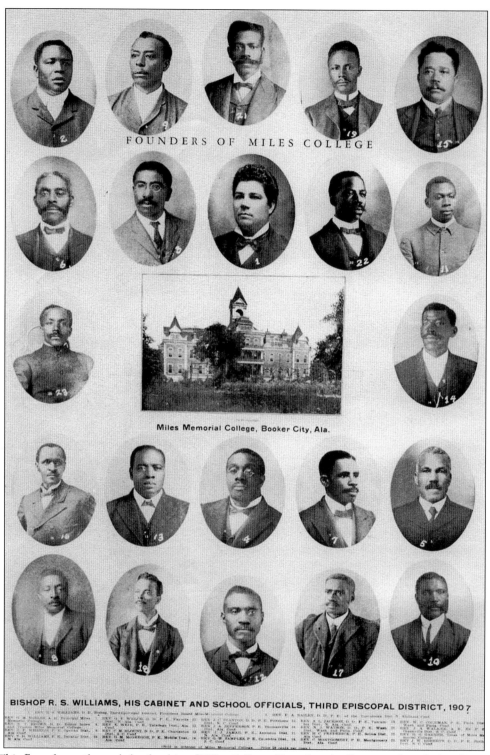

FOUNDERS OF MILES COLLEGE

Miles Memorial College, Booker City, Ala.

BISHOP R. S. WILLIAMS, HIS CABINET AND SCHOOL OFFICIALS, THIRD EPISCOPAL DISTRICT, 1907

This flyer shows the early leadership of Miles College. Note that the flyer misidentified Williams Hall (center) on the Fairfield campus as a building on the Booker City campus.

Pictured here is the freshman college class in teacher training *c*. 1918. By the mid-1920s, Miles College had become the principal training ground for African American teachers in the Birmingham area.

From the beginning, Miles offered a wide range of liberal arts courses not found in many other historically black colleges in the South, including Greek, Latin, literature, and rhetoric. Still, there were numerous courses at the college designed to impart practical skills, such as this 1918 sewing class.

The Miles Memorial College catalogue states, "The Summer School of the College is one of the regular State-approved Summer Schools. The first session opened from June to July with an enrollment of 153 students. We shall easily enroll 300 in the 1919 session. Two states and fourteen counties were represented in the 1918 session."

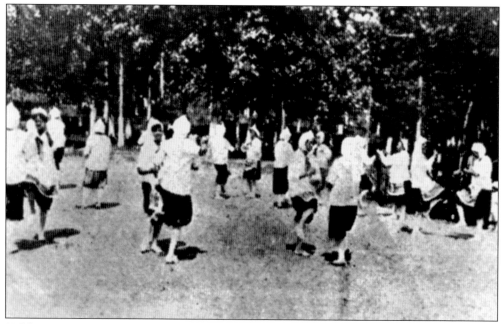

"Athletic sports are encouraged among the students and regulated by a committee on athletics consisting of members of the faculty," reads the 1917–1918 school catalogue.

Three

YEARS OF HOPE,
DAYS OF STRIFE
1918–1936

Miles Memorial College grew in the years following World War I. It added a men's dormitory, which was destroyed by fire and rebuilt, and it expanded its curriculum. Pres. Mack P. Burley initiated an ambitious campus expansion program in 1926–1927, adding the administration building that was later renamed Brown Hall after Pres. Robert T. Brown. The General Education Board of New York, the CME and ME (South) churches, and others helped the college realize part of this expansion program. Burley wanted to build a science hall and a "Model Home" for the women in the teacher training and senior classes to improve domestic life throughout the South. Most ambitiously, Burley wanted to acquire a million dollar endowment to secure Miles's financial future. These ambitions never came to fruition, but Burley had put Miles Memorial College on the road to expansion. Through the 1920s, the college added other buildings. The federal Works Progress Administration provided materials to build two army barracks for student housing and, later, classroom space.

Burley augmented the academic curriculum. He continued the primary and secondary programs to correct the educational deficiencies of entering students and expanded the teacher education course, making Miles a leading center in educational training. Miles grew too as a classical liberal arts college and embraced this ideal at a time when this was downplayed in favor of the Tuskegee-style vocational education for African Americans. This curriculum was in full accord with the CME vision of higher learning and Christian duty. Miles sought to educate the individual for self-government and civic leadership. In pursuit of this ideal, the college required its students to study English, rhetoric, Greek, and Latin, as well as Christian and Methodist church history. The aim was to "give to students that refinement and culture which come as a result of training in the arts and sciences."

President Burley planned for 1928 to offer a new business program with courses such as accounting, labor problems, banking, and finance. He also planned a business preparatory high school course featuring vocational classes such as typewriting, mimeographing, and bookkeeping. Burley even planned a course in agriculture on the Tuskegee vocational model, and he expanded home economics into an industrial department for women, with

high school domestic arts and science courses. The onset of massive debt and the Great Depression would end these ambitious expansion plans.

Miles Memorial College sponsored extracurricular activities that emphasized "training into citizenship rather than training for citizenship" to ready students for the ranks of America's self-governing citizens. The college encouraged students to participate in some type of extracurricular activity, such as literary societies, the debate team, or dramatic and musical festivals. Religious activities were essential to the Miles Memorial College mission, and it offered the YMCA and YWCA, prayer meetings, church, and Sunday school.

The terms of presidents Robert Brown, George L. Word, and Mack Burley, spanning from 1918 to 1927, created a period of expansion and hope. After 1927, growth ended as the CME Annual Conference and trustees ceased contributing to the construction or program expansion. College debt soared, but President Burley made cuts in college operations and obtained financial assistance from student organizations, friends of the college, and the government.

The Great Depression struck America with full force as President Burley ended his term. Many colleges, like Miles, suffered. Enrollment sagged from 573 in the mid-1920s to 330 in 1934, yet Burley continued to improve the college by securing a Julius Rosenwald Fund grant to purchase library books and hire a librarian. Brooks Dickens replaced Burley as president from 1931 until 1936 and continued to fight for Miles's life. In 1934, the State Board of Education disapproved the summer session at Miles Memorial College. That action starved the college of revenue and slowed state teacher certification in the education program. This threatened the viability of the college. Many feared Miles would close, but there were some champions. The John F. Slater Fund, a philanthropic organization that had funded black educational endeavors since 1882, contributed support to pay faculty salaries in 1933 on the condition that President Dickens put the college's financial affairs in order.

President Dickens and the board of trustees took drastic action to avert the looming catastrophe. They put Miles into the hands of a managerial committee from the CME and Methodist Episcopal (South) churches. In 1935, the trustees amended the college's charter to enlarge the board to include members from the CME Conferences of Alabama and the General Board of Missions of the Methodist Episcopal (South) Church. This action regained lost confidence and led to renewed funding. The Slater Fund increased its contributions to $10,000 by 1936, while the Methodist Episcopal (South) Church provided support for the school of religion and home economics department.

During these difficult years, President Dickens added new programs to attract students. In 1931, he sponsored a tour of the American West, giving students the opportunity to travel with college credit. He established a mortuary science school in association with the Welch School of Embalming, the largest such black-owned institution with one of the best forensic laboratories in the state. This added another professional field to the college curriculum. The most radical change that Dickens made was to streamline the curriculum. He dropped the model primary and secondary schools that served the education curriculum and retained the liberal arts or senior college courses and the teacher training program.

Miles had survived the most difficult days of the Depression but remained in difficult circumstances. In 1936, William A. Bell became president for a second term (his first term was in 1912–1913). He would usher Miles through the worst years of the Depression, the expansion of World War II, and challenges of the 1950s.

For the Miles Memorial College alma mater, Catherine Lavender Robinson wrote lyrics to the old Welsh air *All Through the Night*.

Bishop R. T. Brown, fifth president of Miles Memorial College (1918–1922), initiated the first building program for the college.

Miles Memorial College took "Forward through Christian Cooperation" as its motto in 1926. This seal memorialized the college's CME origins and its Christian inspiration and mission. The seal symbolizes the light of knowledge and the goal of moving the black community forward through the cooperative efforts of the CME and Methodist Episcopal (South) churches, as well as the broader Birmingham community.

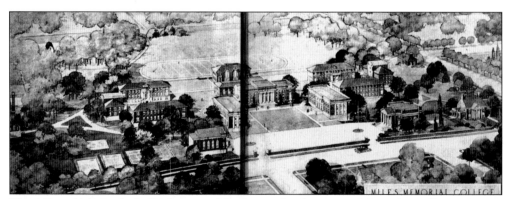

This is Pres. M. P. Burley's 1926 vision of the future development of the Miles College campus. There is the addition of male and female dormitory buildings, a science building, library, and chapel, and a gymnasium, dining hall, infirmary, and teacher homes. The campus buildings would be heated by a centralized power house. President Burley's vision was a bold one, but it was only partly fulfilled. For years, excessive debt would stifle growth and force his successors to impose a stringent regime of debt and cost reduction that would plague Miles until the 1950s.

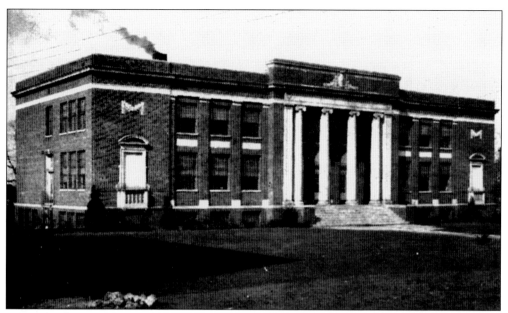

Brown Hall was built in 1927 at a cost of $150,000, half of which was donated by the John D. Rockefeller General Education Board. The CME Church donated $25,000, Methodist Episcopal Church (South) donated $20,000, and the citizens of Birmingham and Fairfield donated $30,000. The building housed the library, college laboratories, some classrooms, administrative offices, and the auditorium. It was named in honor of Bishop Robert T. Brown, president of Miles Memorial College (1918–1927) and chair of the board of trustees. The library was housed on the second floor and equipped with standard facilities including several thousand books purchased with a grant from the Julius Rosenwald Fund. The newly renovated Brown Hall currently houses the college administration and auditorium.

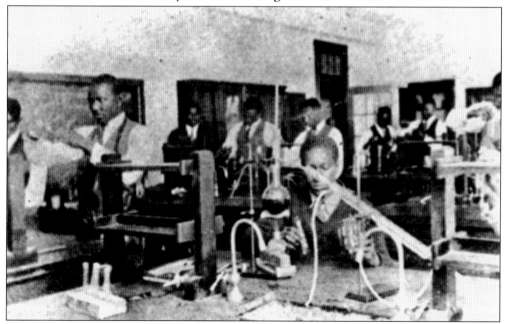

These unidentified Miles students are conducting an experiment in a 1929 chemistry class.

A. L. Welch, president of the Welch Brothers Undertaking Company, would serve on the Miles Memorial College Board of Management in the 1930s. He established the Welch School of Embalming at Miles Memorial College. The Welch brothers' firm was the largest such black-owned institution in Alabama, with one of the best forensic laboratories in the state. The School of Embalming boasted a faculty of six instructors, including two physicians, and offered day and evening classes.

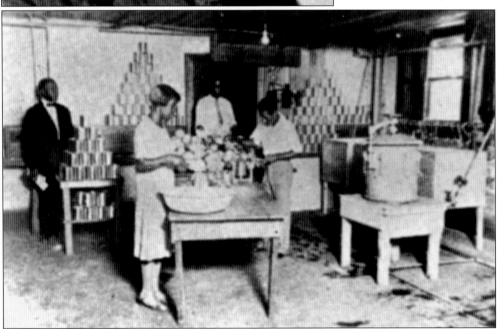

In the 1920s, Miles Memorial College had its own cannery, pictured here. According to the 1928–1929 college catalogue, it consisted "of large steam high pressure boiler, three steam galvanized insulated steam vats, two sterilizers, an autoclave or retort, a sealer and other smaller pieces." Students are shown here canning various foodstuffs produced in the college gardens.

Four

THE BELL YEARS
1936–1961

William A. Bell, who had already served the 1912–1913 term as president and later as dean, was again elected president in 1936. He held that office until his death in 1961. During his tenure, Bell carried the college through some of its most difficult years. Educated at Paine College and Columbia University, he was among the earliest faculty of Miles Memorial College, teaching mathematics and Greek.

Bell's most immediate task on assuming office was to put the college on a firm financial footing and guarantee its survival. The college groaned under a debt of $120,000 and had only a small operating budget of $27,000 for its 196 students and 16 faculty members. Faced with bankruptcy, the general board of education had threatened to close the college. Bell launched several capital campaigns to pay down the debt and enhance the school's endowment. In 1939, he launched a statewide financial rally at Thirgood CME Church in Birmingham to celebrate the Diamond Jubilee of the "Freedom of the American Negro" and raise money to clear Miles Memorial College of debt that had for years prevented the college from receiving other outside funding or even operating properly.

The Alabama CME Conferences proclaimed 1939 a "Diamond Jubilee" to mark the 75th year since emancipation and to celebrate Miles Memorial College as an institution intended to "prepare men and women of our race for worthy citizenship and successful living." In the Jubilee booklet, President Bell praised the sacrifices that made Miles possible and the church members who had already paid $60,000 of its debt. He intended to use this rally to finish the job.

Bishop Henry Phillip Porter, chairman of the board of trustees, and President Bell, with the endorsement of the CME and Methodist Episcopal (South) churches, requested from parishioners a dime for each year of freedom, or $7.50. G. C. Emmons, a member of the Methodist Episcopal (South) Board of Missions and Miles Board of Trustees, predicted, "If this debt can be lifted . . . the school will enter upon a new era of service." The Diamond Jubilee became a model for future efforts such as the Victory Drive in 1941, designed to pay Miles's remaining mortgage, and the capital drive in 1948, another fund-raiser. President Bell fought debt throughout his career and put the college on a firm financial ground that allowed it to prosper.

Outgoing president Dickens outlined the college's liberal arts mission, which Bell supported, as designed "to train students for service to God and for leadership among their fellow men; to develop them into representative Christian citizens; and prepare leaders for democracy."

Bell envisioned Miles as the training ground for black citizenship, but in a different model than either the Tuskegee philosophy or the Niagara movement model of civil rights. In pursuit of this goal of Christian citizenship, Bell stressed academic achievement combined with religious instruction and inspiration.

Bell's policy attracted students to Miles; the college achieved an enrollment of 639 by 1941. He appointed additional faculty, raised academic standards, established a ministries school to train future CME preachers, built a cafeteria, and installed outside benches to add to the campus ambiance. These improvements gained for Miles much press attention.

College life at Miles had improved during these years despite economic hardship. In an important respect, the college became a sanctuary from the Depression by providing a vibrant educational, cultural, and even athletic experience with its popular, if not winning, football team. J. B. Sims wrote in the *Birmingham Weekly* in 1940, "It's soul invigorating to walk on a beautiful college campus and mingle with the culture in its entirety." Bell sponsored important cultural events, including a symphony concert given at Miles by the noted musician and conductor Bohumir Kryl. A *Birmingham World* writer noted that music fans who like it "high and spirited" would appreciate this concert and quipped the "swing is not always the thing."

In May 1940, John Saxon Childers, professor of literature at Birmingham Southern College and columnist for the *Birmingham News,* wrote a Sunday feature article entitled, "Miles Memorial—A Monument to Education." He praised Miles, pointing to it as a major institution that deserved notice. Childers interviewed President Bell, who shared his vision of educating students as Christian citizens. "We are looking to the time when any Negro boy or girl can come to Miles Memorial College and receive an education that would fit them for any profession or any trade. We want to send our boys and girls out capable of contributing their part to the betterment of their group and the community as a whole."

Miles students did many things to support the nation during World War II, such as conducting scrap drives. Other Mileans served America in its armed forces. They and many other black Americans looked to the post-war world for an amelioration of their condition in society. In 1944, several soldiers expressed their post-war hopes in letters to *The Milean*, the student magazine. Pvt. Isom Morgan wrote that "the future he will want is so great that nobody is going to hand it to him on a silver platter. That is why he wants a fighting chance, an opportunity to go ahead. He will want a plan, a future of his own in a free land . . . with no limits on how far he can rise. That is the America he is fighting for! That is the America he will want in the post war world!" Lt. Ivey Leftwitch, one of the famed Tuskegee airmen, wrote optimistically that, "By industrializing the South many problems will be solved. The result will be better economic conditions and higher standards of living." Leftwitch concluded his letter thusly: "In the words of Wendell Wilkie, I have this thought: 'At the end of the war the freedoms which we have lost, must be re-won and restored, *not part, but all of them.*' If we fail to do that, then history will write it down that the victors were the vanquished." These soldiers saw that the nation owed American blacks a debt of gratitude, liberty and respect for their efforts during the war. This was a debt that could not wait.

President Bell, too, looked beyond the war to the future place of the college in Alabama. In 1941, he and the board of trustees changed the name of Miles Memorial College to Miles College. In 1943, he commissioned "A Study of a College for Negroes in Relationship to the Industrial and Community Interests of the Area in which it is Located" to determine the socioeconomic characteristics of Birmingham's black community and help the college provide it with adequate educational services. The study recommended that Miles stray from its traditional liberal arts mission and reinforce its teacher education, ministerial, and home economics curriculum. It also suggested the college add business courses.

President Bell enacted these recommendations without abandoning the traditional mission of the college. He added a vocationally oriented business division that offered secretarial, accounting, and business law courses to train students entering a business career and to

reinforce the education curriculum. During the war, President Bell paid off the bulk of the college's debt and improved its academic standing. After the war, enrollment grew dramatically. In 1948, Miles College registered 1,226 students. This progress cleared the way for further campus construction. In 1943, Bell had the Practice School Building remodeled. The refurbished structure, now named in honor of the philanthropist Erskine Ramsay, who donated funds for the project, housed a new library.

Miles, like other black colleges, was accredited through the Southern Association of Colleges and Schools (SACS). During the era of segregation, SACS accredited these institutions by a less rigorous "Grade B" accreditation system. This two-tier system took into account the difficulties that black colleges faced in maintaining financial stability and adequate facilities, attracting and retaining faculty, and drawing on large alumni funds. In the wake of the landmark Brown Decision of the U.S. Supreme Court, this separate accreditation process was eliminated by SACS. The accrediting organization now had to judge all colleges and universities by the same standard.

In October 1958, a special SACS committee rescinded Miles's accreditation, citing an inadequate library, ramshackle campus buildings, and an inadequately qualified faculty. In particular, SACS demanded that Miles either veneer or demolish its three wooden class buildings, which the organization deemed unsafe. President Bell had these structures remodeled. Today they are known as Alabama and McKenzie Halls and the Social Science Building, later converted into Miles Law School. Bell began construction on a new library building and acquired additional books to meet SACS standards. The new library was completed after the president's death and was named Bell Hall.

President Bell is often seen as being unsympathetic to the civil rights movement as it developed in the 1960s, and scholars have cast him inaccurately in the Tuskegee mold. Bell was a complex man who looked deeply into the social problems of the day while remaining true to his convictions. Bell's view of the Miles mission informed his view of black civil rights. He saw the liberal arts degree as the training ground for Christian leadership whose recipients were prepared for and would participate in citizenship. His mission was to train property-holding citizens ready to exercise a role in the broader society. This indicates that he saw both the accommodation and struggle models of civil rights as inadequate. The 1943 Miles study exposed Birmingham's blighted black communities as a drain on the community at large and concluded that the only solution was to provide education to the men and women who would pull the black community up. Citizenship was not a given to Bell, but something that must be worked for and worked at.

In the 1940s, Bell made Miles a base for the Southern Negro Youth Congress. This organization included many of the leading black intellectuals of the day, with many Miles faculty and students as members. He later rejected its communist leanings as extremist and destructive. Some charitably saw his reaction as one of protecting Miles from white retribution, but it would be more accurate to state that he rejected such ideology on principle.

As complex as his views were, Bell was an austere man who inspired both reverence and fear. Exacting, principled, and pragmatic, he followed his own lights. It is not surprising that the people around him saw him very differently, whether as personal hero or hard task master.

Richard J. Arrington Jr., class of 1955, served on the faculty and as dean in the 1960s. He saw Bell as "a gentleman who stood about five foot ten inches. He would be properly called a patrician or a man of aristocratic bearing. He was always well dressed in a three piece suit. He micro-managed the college, supervising everyone from janitors to administrators. We all, including students, respected and feared him. No one I know ever got 'close' to Dr. Bell. Given the fact that the college was dirt poor, Bell has to be considered a good and demanding administrator."

Gwendolyn J. Moore Bowie, class of 1962, knew President Bell toward the end of his life. She remembers him as having an "aura of smiling 'aloofness.' He was a man of principle and

sincerity. However, he did have a unique sense of humor that was exhibited so rarely that [it] was memorable. His very slow, distinctive speaking style gave the impression that he never spoke a word without thinking it through. In fact, he was meticulous about everything . . . his speech . . . his walk, his general appearance . . . He talked very little, yet he was much respected."

William A. Bell accomplished much as president of Miles College. He pulled the college back from the brink of bankruptcy and put it on a course toward expansion. He maintained its liberal arts vision and, in many ways, put the college on the map. Certainly he suffered setbacks, but when he passed away in 1961, it could be said that he put his personal stamp on Miles and opened it up to many possibilities as an important Birmingham institution.

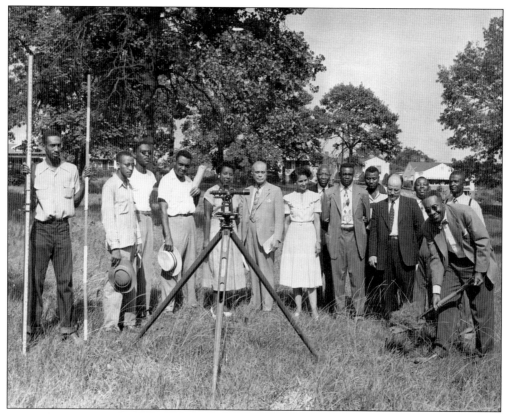

Ground is broken on the new athletic field in the 1950s. President Bell stands in the center, with Alice Allen to his right. Bishop Doyle is fourth from the right.

William A. Bell, a graduate of Paine College, Columbia University, and Lane College, came to Miles Memorial College in 1908, teaching mathematics and Greek. He became president in 1912 and left to become dean of Paine College from 1913 to 1917. He returned to Miles and served in numerous CME Church positions as well as on the college faculty. He served as Army YMCA secretary from 1917 to 1919; regional secretary of the Interchurch World Movement from 1919 to 1930; field secretary for Paine College from 1930 to 1934; secretary of education of the CME Church from 1934 to 1936; and as executive secretary of the CME Commission on Cooperation and on the council of the church, both from 1930 until his death in 1961. He returned to the office of president, serving from 1936 to 1961. He was also grand sire archon of Sigma Pi Phi. Bell authored the work *Missions and Cooperation, ME Church South and CME Church* in 1933. Bell brought Miles through the Great Depression and World War II and into the civil rights era. He placed the college on a sound footing and expanded its facilities and offerings. Known as a firm president, he was also a kindly man who never denied any prospective student an opportunity for education.

This is a boule held by Sigma Pi Phi Fraternity at Maryland State College at Baltimore in August 1948. A boule is a convention of the officers and members of the fraternity. The term is named after the ancient Athenian boule. Sigma Pi Phi was led by an executive committee of officers. President Bell held its highest office of grand sire archon. Members held the title of archon. The black elite at the turn of the 20th century founded many of the Greek-letter fraternal organizations. A group of six black professionals founded Sigma Pi Phi in Philadelphia in 1904. The members saw themselves as their fellow member W. E. B. DuBois did—as the elite "talented tenth" who would lead the black community. They engaged in community service and outreach, often in conjunction with other organizations such as the NAACP.

This meeting of the Southern Association of Colleges and Schools (SACS) in Atlanta in 1958 would rescind the accreditation status of Miles College and of other black colleges after the passage of desegregation. President Bell is third from the left, fifth row up.

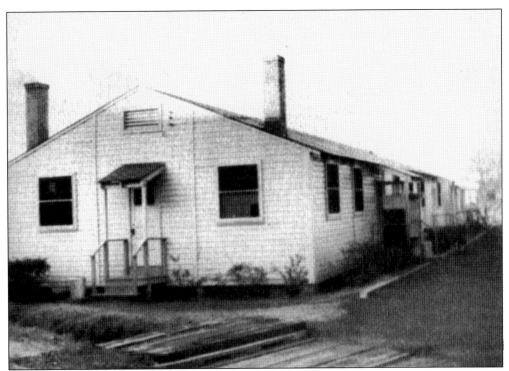

Federal Works Administration Building Number One (above) was an old U.S. Army barracks that was rebuilt at Miles. Originally used for student housing, it was later used as classroom space. In the 1950s, when SACS required that this structure be re-veneered, it was rebuilt as a two-story building (below) and used for the music division. In 1960, the board of trustees named this building after Rev. Robert M. McKenzie and Mrs. Trudie H. McKenzie, two of Miles College's senior faculty.

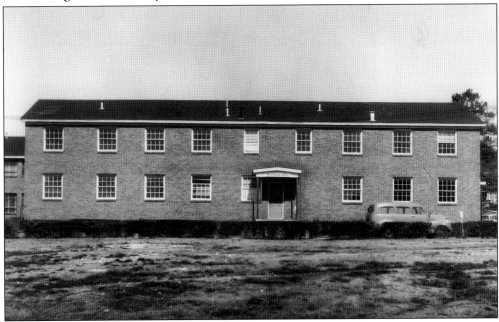

Federal Works Administration Building Number Two (above) was a scrapped U.S. Army barracks rebuilt at Miles. Originally used for student housing, it was later used as classroom space. In the 1950s, by SACS mandate this structure was rebuilt as a two-story building (below) and used for the social science and education divisions.

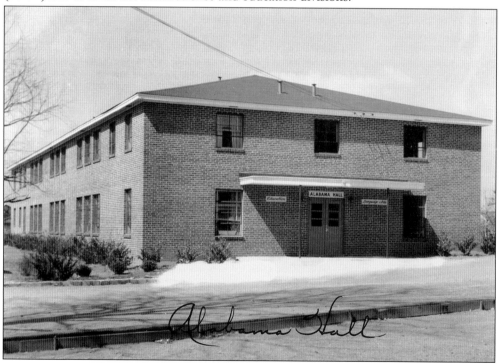

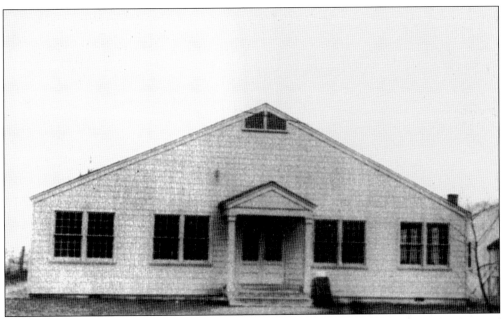

Federal Works Administration Building Number Three was built in 1951 from the donated materials of an Army barracks. SACS required that this building be re-veneered. Completed in brick veneer in 1959, this building retained its original form and was used as the social science building. It now houses the Miles Law School. The photo below was taken in the 1960s.

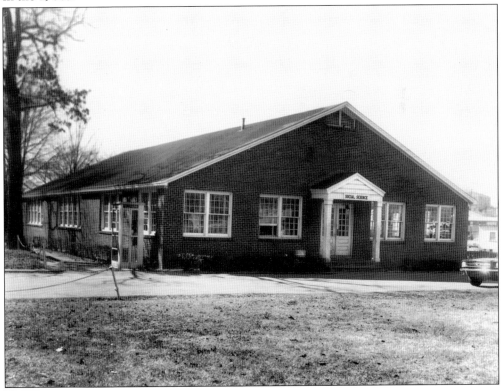

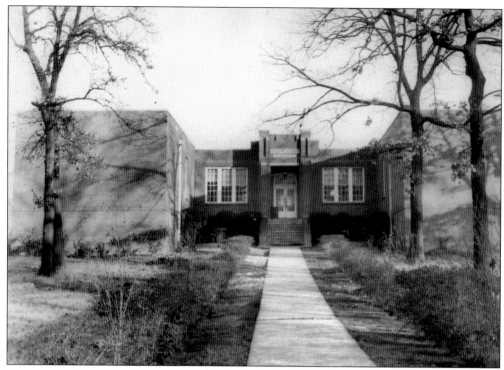

Prior to World War II, the future Ramsay Library was the Miles Memorial Practice School Building. The school was transferred to the Fairfield, Alabama, public school system. During the early war years, this building was used for regular academic courses. The college remodeled the building into the Erskine Ramsay Library in 1943, moving the library facilities from Brown Hall. Miles completed this building with the assistance of Birmingham philanthropist Erskine Ramsay. The Ramsay Library building was called "House of Knowledge" by Miles Memorial College students.

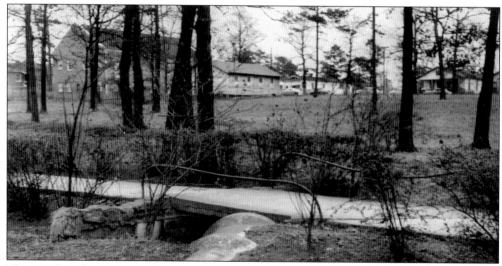

The "Bridge of Success," a famous landmark at Miles College, is pictured here in 1952. It is the path over a small culvert between Brown Hall and Ramsay Library, which students would pass over coming and going to class.

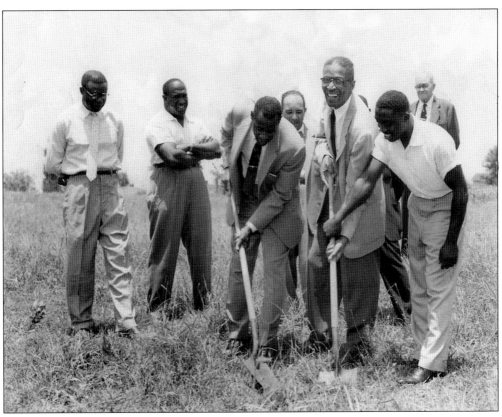

Head coach Thomas J. "Mule" (later "Papa") Knox (center above) breaks ground on the new field house (shown below) in 1956. Coach Knox was a member of the Miles faculty since the 1930s, serving most distinctively as director of athletics.

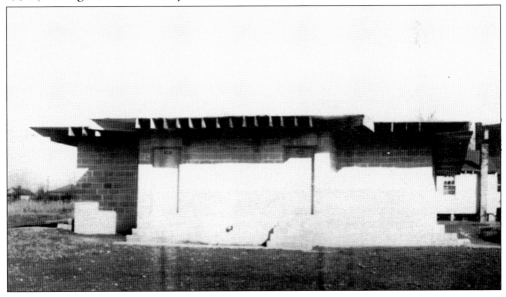

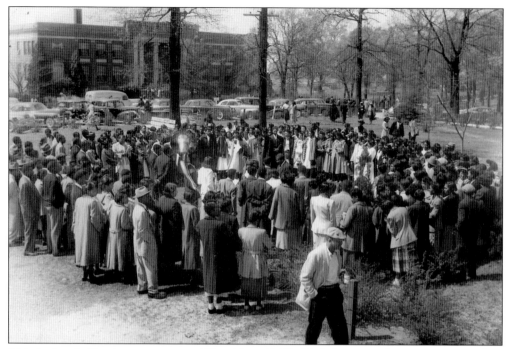

This is the dedication ceremony of President Bell's birthday-tree planting on Founders Day, March 28, 1952. The senior class planted a tree annually for the president's birthday, which was February 16, 1882. The planted tree is dedicated on Founders Day. Brown Hall is in the background.

This was the most famous tree on campus in 1952. Called "The Tree," it was planted in honor of President Bell near Brown Hall. Many Miles Day events were held before it.

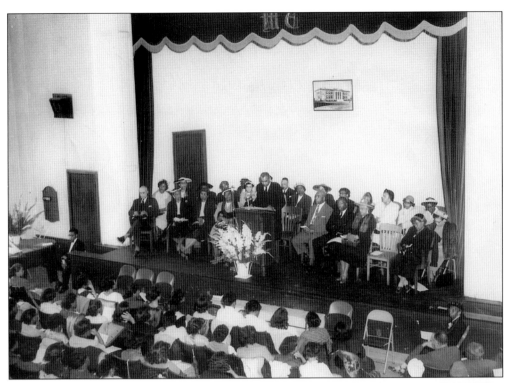

This is the Founders Day ceremony held in Brown Hall Auditorium on March 27, 1954. President Bell is on the far left on stage.

Pictured here is Bishop Betram W. Doyle giving his Founders Day speech on March 27, 1954. Bishop Doyle was president of the board of trustees in the 1950s.

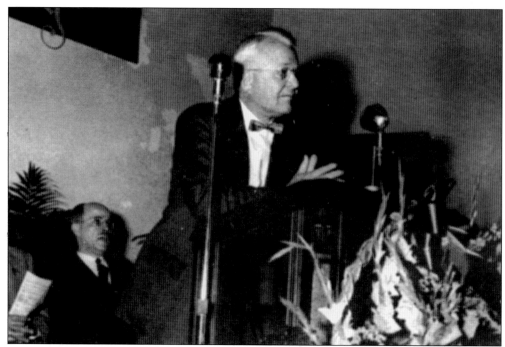

Mr. E. L. Norton, chairman of the executive committee of the board of trustees, gives a rousing Golden Jubilee Anniversary speech.

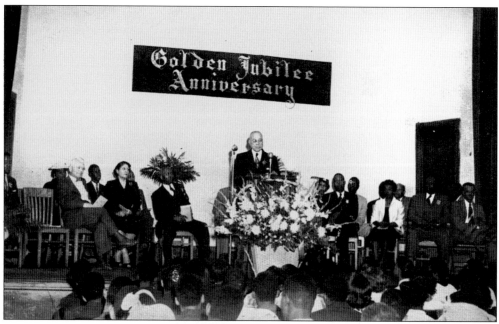

Pictured here in March 1955, President Bell gives his Golden Jubilee Anniversary Speech celebrating the founding of Miles College.

Previously an instructor of history, Frank Pearson became the director of instruction in 1955. This office, the forerunner to that of academic dean, supervised seven academic divisions, including business administration, English, education, home economics, physical education, social sciences, and natural sciences. There were 31 full-time faculty teaching at Miles in 1955.

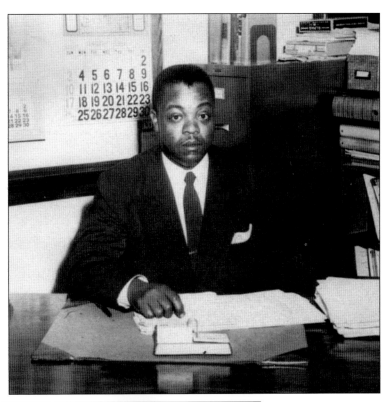

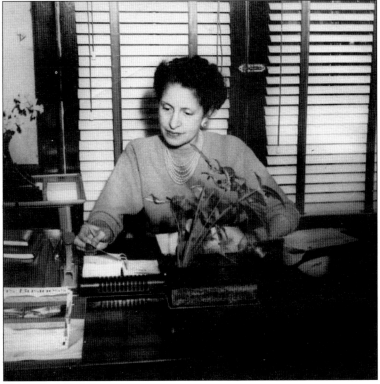

Mrs. Alice P. Allen came to Miles in the 1940s after earning her M.B.A. at the University of Chicago in 1943. She served as administrative assistant to President Bell and became director of the business division when it was founded at the end of World War II.

At one of the college chapel events, President Bell awards tokens of thanks to those faculty who have served for 10 years or more. Pictured from left to right are President Bell; Robert McKenzie, professor of religious education; Thomas Knox, head coach and director of the Division of Physical Education; Alice Allen, director of the Division of Business; Edythe Jones, director of the Division of Home Economics; Annie B. Jackson-King, accounting instructor; Myrtle W. Blissett, director of the Division of Education; and Willie Mae Bell, English instructor.

Robert M. McKenzie, professor of religion and history, served Miles from 1934 to 1961. Mrs. Trudie McKenzie, professor of mathematics, came to Miles in 1910. She served as dean of women and matron. Together they shaped the lives of many Miles students.

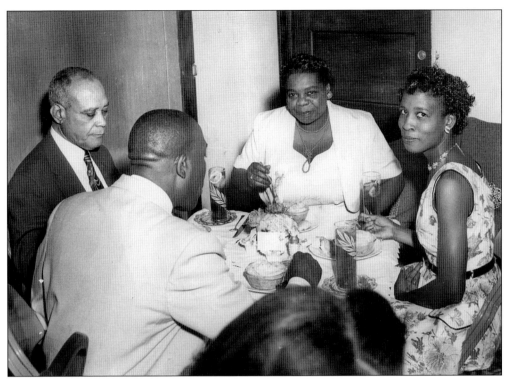

Pictured here in the mid-1950s is President Bell (left) at a faculty luncheon with Myrtle W. Blissett, chair of the Division of Education (center) and Ms. A. M. Austin, the first Miles graduate to receive the E.D. (right). Education has been a flagship division at Miles College. The college has always sent its well-trained teachers to school systems in Alabama and neighboring states.

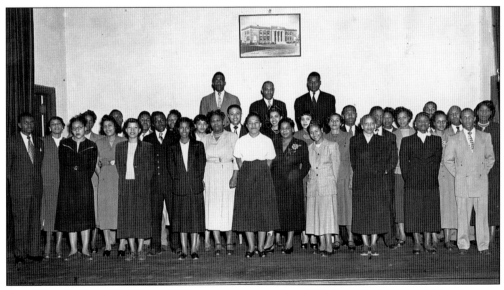

The Miles College Division of Education recruited qualified students as cadet teachers to introduce them to the teaching profession. These are the cadet teachers on stage at Brown Hall in 1949. Professor Blissett (center) poses with the group.

Pictured here is Ardenia A. Rambeau's French class in 1955. He studied at the Sorbonne in Paris and Université de Laval in Quebec.

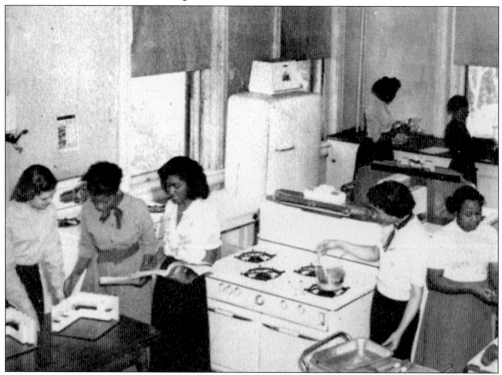

Home economics was one of the academic programs of Miles College. Its mission was to help students develop a satisfying home and family life. Cooking was a cornerstone of this program and included classes in food science, nutrition, and cookery. This is a cooking class taught by Mable Bell in 1955.

The home economics program was designed for the liberal arts students and those who needed background for related professional fields. The division taught classes in home management and child development. Clothing was an important part of the program, with classes in textiles, clothing, and cloth production. Letitia King taught clothing and art. Here, she is teaching a millinery class in 1955.

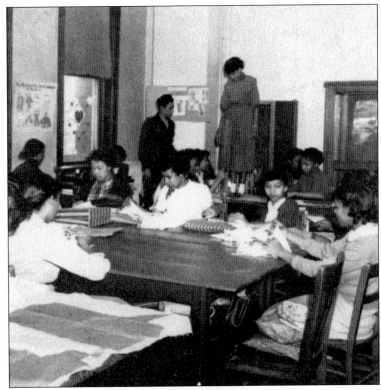

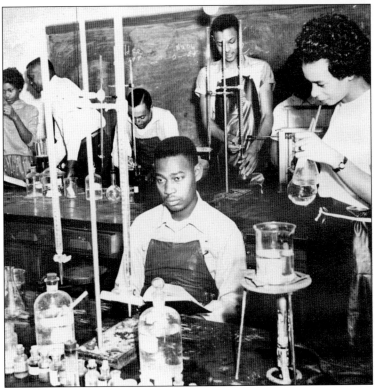

Chemistry was one of the standard science courses offered at Miles College. They included a battery of over 12 courses such as inorganic, organic, and physical chemistry. There was even a course in water analysis that studied local water supplies. Pictured here is a typical chemistry class in 1955.

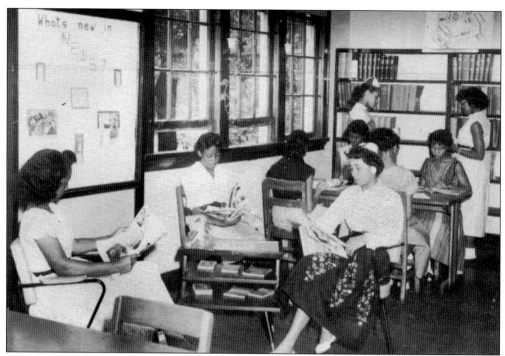

The well-equipped Ramsay Library, according to the Miles catalogue of 1948-1949, was planned to facilitate student and faculty study and cultural enrichment. It contained several thousand books and periodicals and was affectionately known as the "House of Knowledge." Students are pictured reading in 1955.

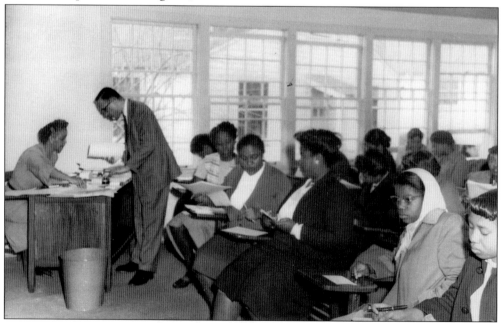

Pictured here are students registering for class in 1951. The woman at the desk is Carrie C. Robinson, chair of the Division of Languages. The man standing is Frank G. Saunders, instructor of English.

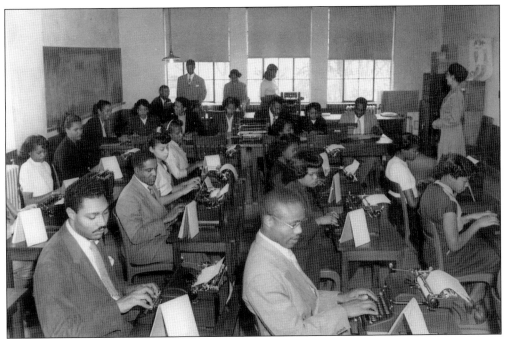

This is a typing class in the business division in 1952. President Bell organized this academic division as a result of the 1943 demographic study of Birmingham. The study recommended that Miles institute more vocational courses. Alice P. Allen's division was geared toward this type of business coursework, while economics remained in the liberal arts college. Allen is standing on the right, looking over the progress of a student.

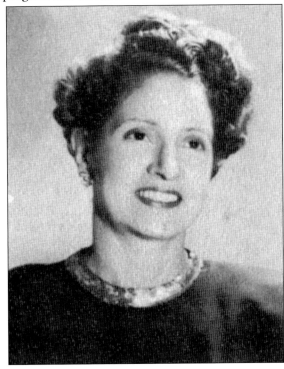

Alice Allen served Miles College as administrator, division chair, and community leader. She was an example of the accomplishments women were capable of and the role the college plays in fostering those accomplishments.

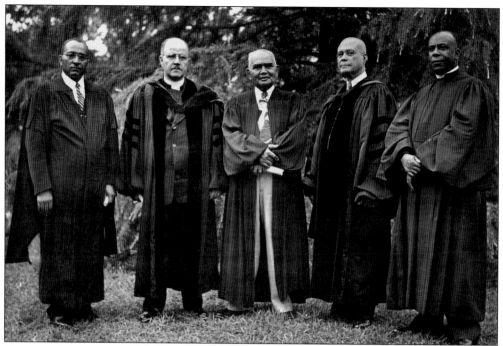

This is a portrait of members of the board of trustees with President Bell at a Miles College commencement ceremony in the 1950s. From left to right are unidentified; Bishop Doyle, president of the board of trustees in the 1950s; Bishop Porter, the former president of the board; President Bell; and unidentified.

Pictured here is the dedication service during the 1956 commencement in Brown Hall Auditorium.

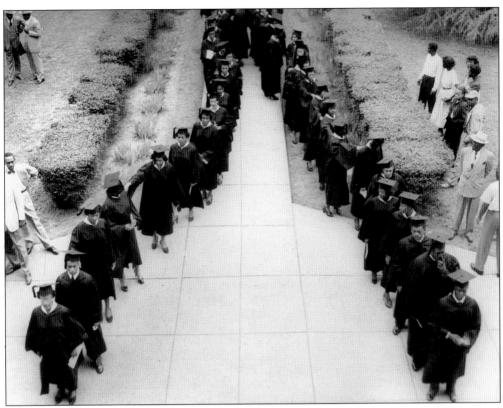

Here students line up outside of Brown Hall in preparation for a commencement ceremony in the 1950s.

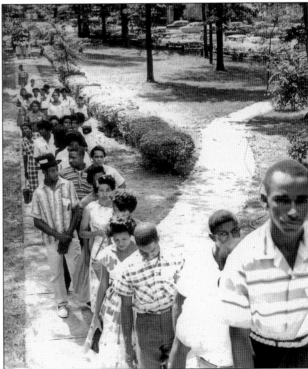

Anxious freshmen go to the reception and coffee hour during student orientation week in September 1958.

Sponsored by the home economics division, the club, pictured here in the mid-1950s, supplemented the cultural aspects in the field of family life otherwise omitted in the class curriculum. Its motto was, "Let us strive to be a club that ranks high in scholarship and school spirit, a club of which Miles College may be proud." Its purpose was to give to students experience in forming a good domestic life. Its annual fashion show furthered an appreciation for good grooming, poise, and clothing selection.

Pictured here is the editorial staff of *The Milean* in 1950. In 1916, Miles established a student paper entitled *The Milean*. It was published monthly and later quarterly during each academic year. This was a student publication with a faculty advisor. The college purchased a printing press to publish this and other documents. Students took pride in publishing the paper and in getting their work into print. *The Milean* included articles of campus interest such as "French Classes to Present Plays," "Negro History Week," "Open Letters from Mileans in Service," or "Dormitory News Notes." The publication accepted advertisements to defray the cost of publication, giving the student publishers not only the experience of publication, but of business as well.

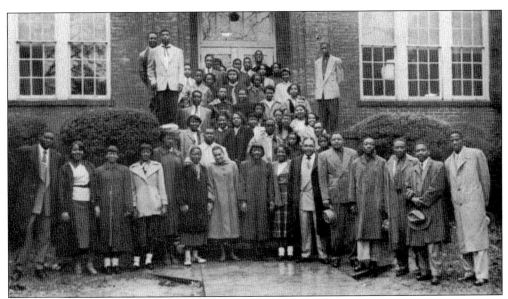

Pictured here is the Natural Science Club in 1951–1952. The Natural Science Club, or Science Club as it was later called, was intended to build an appreciation of biology, chemistry, and physics. It was also intended to stimulate student interest in research and provide an opportunity to gain practical knowledge in using the scientific method to solve problems. Academic clubs were a major part of student academic and social life at Miles. There were 10 of these academic clubs in the 1950s, such as the Stylus Club for English majors, the Physical Science Club to promote science, and the Honor Society to promote overall academic excellence.

The Social Science Club (1955–1956) was organized to foster an appreciation of the social sciences, including political science, sociology, history, and anthropology. The club motto was "To learn, to live, and let live." The faculty advisor, Richard E. Maxwell, stands before the club on the left. The club president, Fred Ross, is standing before the club on the right.

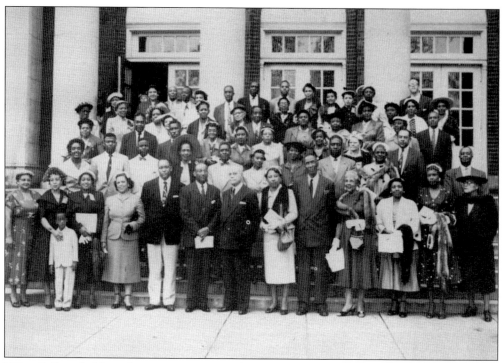

Miles College held an alumni convocation during its Golden Jubilee in 1956. Pictured here are alumni representing the classes from 1915 to 1955.

Representatives of the Semper Fidelis Women's Club present a donation check of $350 to President Bell in the 1950s.

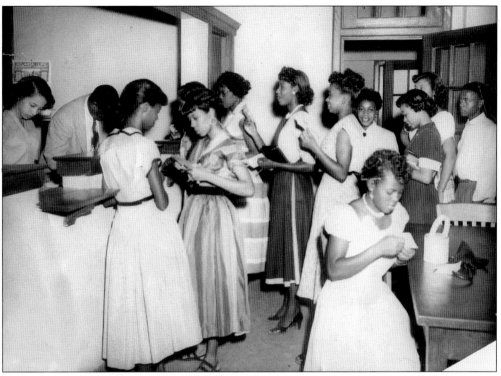

Students conduct business at the bursar's office in 1951.

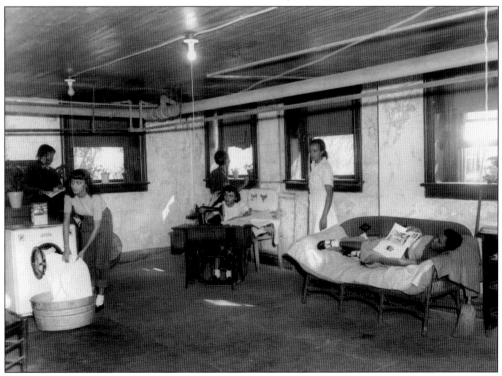

Students relax, sew, and do their laundry in the women's dormitory in 1951.

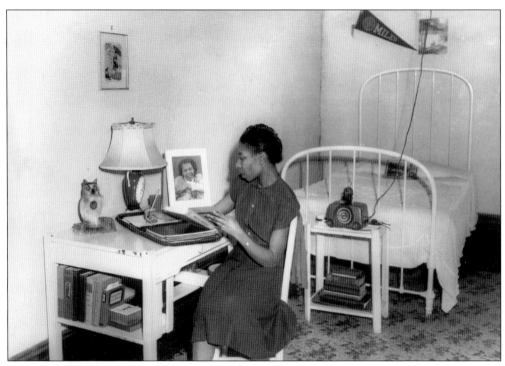

An unidentified student is hard at work in her dorm room in 1951.

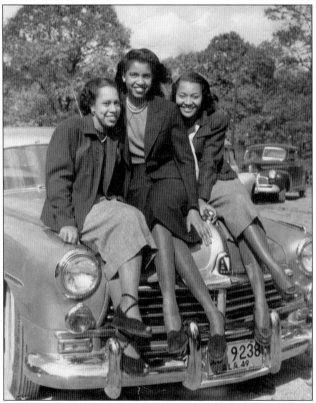

Miss Miles and her attendants reigned over college homecoming activities. Miss Miles for 1949–1950 was Lucille Bell (center), a social science major, and her attendants were Virginia Myricks (left) and Mary Pritchett (right). The three young women relax on a spring day in 1950.

In 1955, Miss Homecoming was Loretta Frazier (center) and her two attendants were LoeVetter Hearns (left) and Theresa Turner (right).

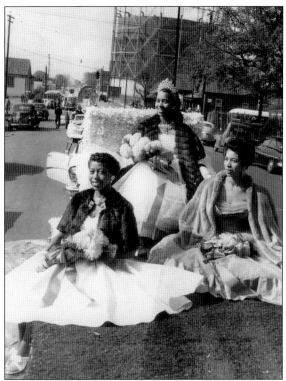

As Miss Homecoming 1956, Marie Lankersley (seated) observes participants in the coronation festivities.

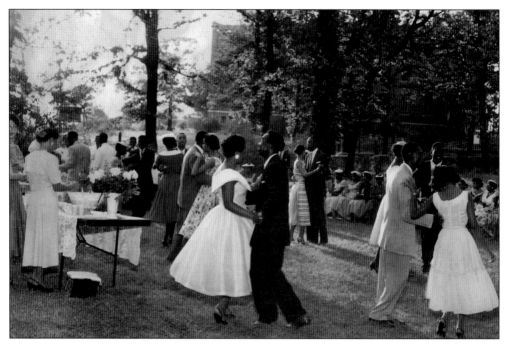

Miles College held several social events for its students during the academic year to entertain and instruct in the social graces. Here is an outdoor senior-class reception and dance in 1956.

A South Seas celebration is held at the Miles auditorium in the 1950s. The college held many cultural events that broadened the students' horizons and were an essential part of their education.

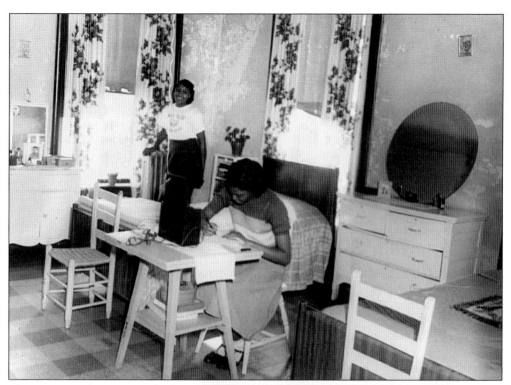

The women's dormitory, which occupied the left wing of Williams Hall, was equipped with comfortable rooms as well as reception rooms and an auditorium. Pictured here is a double dormitory room in 1951. Williams Hall also housed the home economics division in the right wing of the building.

Here are Vateness Rutledge, Miss Miles for 1955–1956, and her attendants in the annual homecoming parade. Rutledge was a physical education major and, along with being crowned Miss Miles, she was voted the most popular senior.

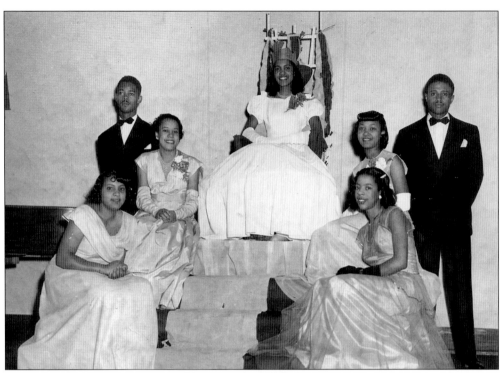

Pictured here is Lucille Bell as Miss Miles of 1948–1949 and her court.

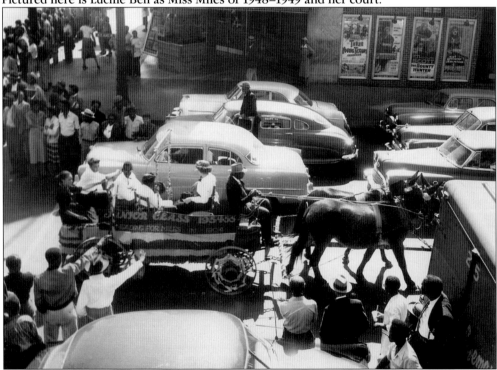

This is the Miles homecoming parade of 1954–1955 in Fairfield. The theme of the colorful mule-drawn wagon is a reenactment of prospective students "Heading for Miles in 1904."

Miles College cadet teachers participate in the March of Dimes Drive in 1955. Miles students often participated in public service individually or in conjunction with college groups such as Greek fraternities or sororities, academic clubs, or with the cadet teachers, as shown here.

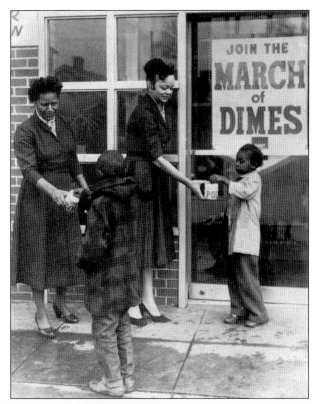

The Miles Day celebration hosted several events, such as cookouts and musical and cultural events. Pictured here is an athletic demonstration in 1949.

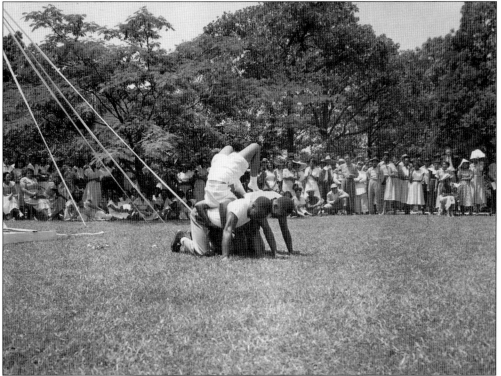

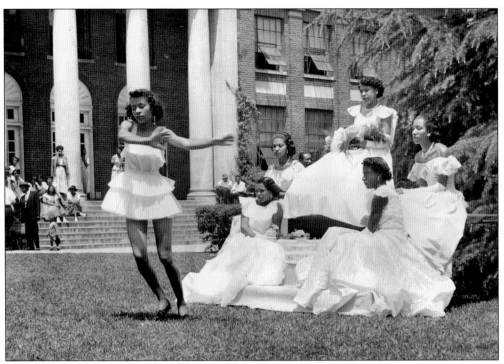

At Miles Day in 1949, a student performs creative dance before Miss Miles and her attendants. Brown Hall is in the background.

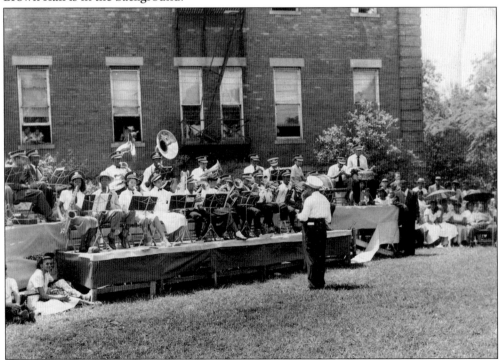

The Miles College Band, shown here in the Miles Day performance of May 12, 1950, included 35 members and 15 majorettes and was under the direction of Iva B. Williams.

The Miles Collegians, a 10-piece orchestra, was organized in 1950 under director Iva B. Williams.

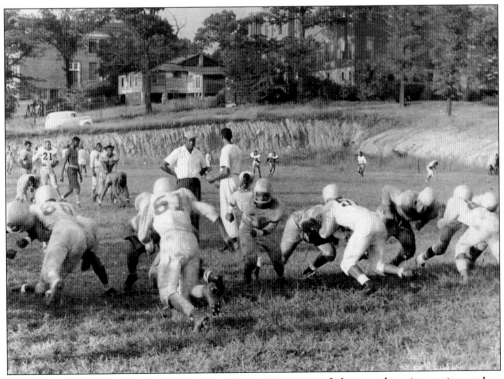

At a Golden Bears football practice in the 1950s, one of the coaches (center) watches a play unfold.

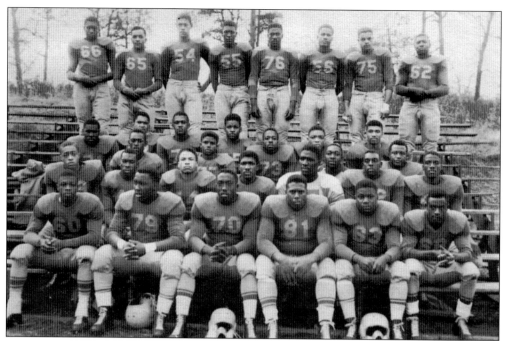

Athletics are an important part of the Miles experience, and football is a cornerstone of the college athletic program. The undefeated Golden Bears football team is pictured here after the winning 1954 season.

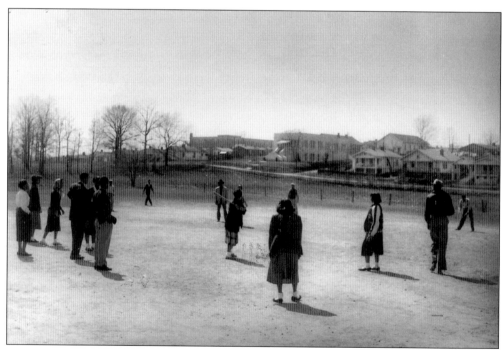

All students could participate in sports at Miles. Intramural sports were popular pastimes. Pictured here is a women's softball game in the 1950s.

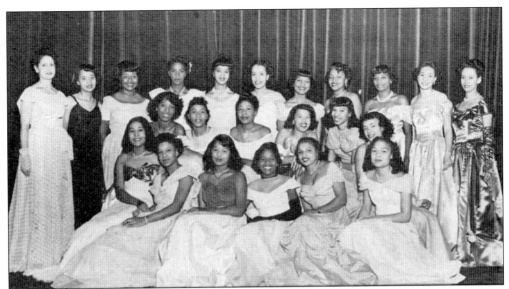

Rho Nu, pictured here in 1949, is a sorority founded at Miles in 1942 by Jeanne L. Chandler. Its Greek letters mean "Reigning Noble Women." This club is intended to "encourage the ideals of womanhood to achieve worthy membership" to society and inspire an appreciation of cultural interests.

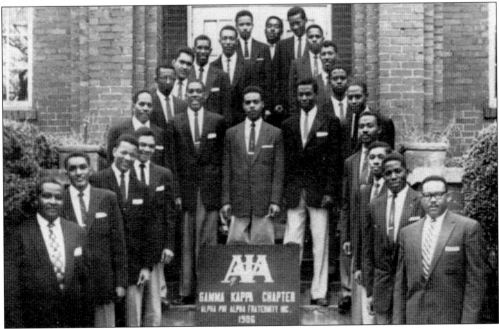

The Alpha Phi Alpha fraternity was founded in 1906 and built the fraternity belfry, the first permanent structure on the Miles campus, that year. Like other black Greek letter college fraternities, it served the black community. Its purpose was "to develop and encourage high scholastic standards, ameliorate the social standing of the race, elevate unity and friendship among college men, and maintain, among the students an interest in college life and the values coming from such interest." Its motto was "First of all, servants of all, we shall transcend all." The Gamma Kappa chapter, pictured here in 1955, was founded in 1947.

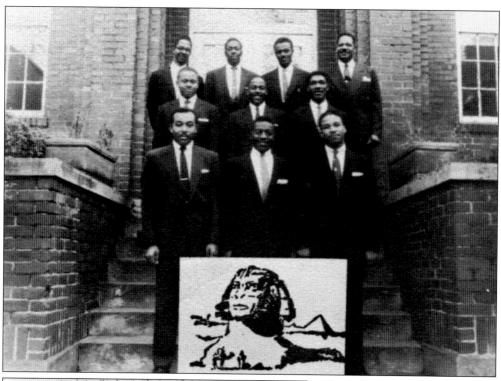

The Sphinx Club was an organization sponsored by the Alpha Phi Alpha fraternity. Pictured here is a group portrait of the members in front of Ramsay Library in 1955.

Alpha Phi Alpha fraternity built the Bell Tower, the first permanent structure on the Miles campus, in 1906. The bell served as the campus alarm clock to rouse students in the morning to come to class and to announce the change of classes. This is a 1970s view. Ramsay Hall is on the right.

Five

THE PITTS YEARS:
MILES AND CIVIL RIGHTS
1961–1971

"In this world you either live or die," Miles College student government president Frank Dukes said in January 1962 as he and other activists embarked on a campaign to defy the racist laws that made life in Birmingham unbearable for African Americans. "It is time that we as black college students take the lead in our struggle against oppression." Momentum for change had been building on the Miles College campus for the better part of a year when Dukes and other students met to form the "Anti-Injustice Committee."

In the months that followed, the students inaugurated a boycott of downtown businesses that maintained segregation. Though the businesses refused to amend their practices and the protest declined in the face of bitter police harassment in June, the goals that the Miles College students adopted influenced the dramatic demonstrations that swept through Birmingham a year later. Those events, fueled by ideals honed at Miles College, captured the attention of the nation and the world, and they began the process of dismantling the Jim Crow system that had served as the foundation of Birmingham since its beginnings almost a century earlier.

While the demonstrations captured national attention, numerous other changes were underway on the Miles College campus during the 1960s. Lucius Pitts succeeded William Bell as president in 1961. In addition to supporting the efforts of student protesters, Pitts began an aggressive campaign to stabilize the college's finances, attain accreditation from the Southern Association of Colleges and Schools (SACS), and improve the Fairfield campus. The efforts produced impressive results, and Miles College gained a great deal of acclaim throughout the decade.

It was activism, however, that gained the most attention. In many ways and on many different levels, Miles College and its students influenced the events that played out in Birmingham, Alabama, and the rest of the region during the civil rights era. In 1955, a young alumna of Miles College named Autherine Lucy applied to the University of Alabama's library school, a graduate program. Since no comparable state program in library studies existed for African Americans, Lucy's application represented a direct challenge to the university's policy of admitting only white applicants. When the school initially rejected her, Lucy took her case to

the federal court system, which eventually ordered the university to admit her. In February 1956, accompanied by Birmingham civil rights leader Fred Shuttlesworth and other supporters, Lucy became the first African American to enroll at the University of Alabama.

Her tenure at the school did not last long. Lucy managed to attend one day of classes on a Friday before disturbances swept the Tuscaloosa campus. On her second day, a Monday, violent mobs pursued her and she was forced to take refuge in a building for three hours before she could be evacuated. University officials initially suspended Lucy "for her protection and for the protection of other students and staff members." A few weeks later, the university's board expelled her. The University of Alabama remained all white for another six years.

Students like Lucy would continue to make universities and colleges central in the fight for civil rights in the years that followed. In 1960, a wave of sit-ins swept the South as students sought to defy Jim Crow laws in restaurants by refusing to leave until they were served. Inspired by this movement, Birmingham activists, led by Miles College student leader Jesse Walker, organized a "Prayer Vigil for Freedom" in Kelly-Ingram Park to coincide with the planned filibuster by Southern congressmen of the Civil Rights Act of 1960. The protest included about a dozen students from Miles and Daniel Payne Colleges and took place on March 1. The students, who held signs and passed out fliers, were quickly arrested, taken to jail, fingerprinted, and photographed. The names and addresses of the arrested students were published in newspaper reports, which provided Klansmen and others with the information they needed to conduct systematic retaliation against the activists. Such a reaction was not long in coming. A few days after the vigil, police and sheriff's deputies stormed into the house of one of the demonstrators, Miles College football player Robert Jones, and savagely beat him, his mother, and his sister. The protests, however, would continue.

Student activists planned a round of sit-ins at downtown restaurants that refused to serve African Americans. On March 31, Walker and about 10 other black college students went into downtown department stores, purchased small items, took seats at lunch counters, and requested service. Police arrested the demonstrators for "trespass after warning." Following the arrests, officials from the colleges, fearing retaliation from white authorities in Birmingham, began to pressure the activists to cease their demonstrations. Walker and other leaders, with Shuttlesworth's encouragement and support, urged the students to keep up their protests. When city officials discovered that Walker and other students had met with Shuttlesworth and encouraged continued confrontations, they were arrested again for conspiring to violate the city's segregation ordinances. Momentum, however, was with the protestors, and sporadic sit-ins continued.

Though the student movement at Miles College drew inspiration from and cooperated with the national and local movements, it remained independent of both. The college continued to produce a stream of strong leaders and rank-and-file activists from its student body in the early 1960s. One such leader was Frank Dukes. At 31 years old, Dukes had served in the Korean War and had worked in an automobile factory in Detroit before enrolling at Miles and becoming student body president.

Other changes swept through the college community as well. Lucius Pitts became president of Miles College in 1961. Pitts had been a member of the Southern Regional Council and had served as executive director of the Georgia Teachers and Education Association, an organization that had 11,000 African American members. By the time Pitts arrived at Miles in 1961, he was already known in the civil rights movement. Martin Luther King Jr. once attempted to recruit Pitts for the top post at the Southern Christian Leadership Conference (SCLC). In contrast to Bell, Pitts generally encouraged the students at Miles, and the college was transformed into a center for civil rights activism during his tenure as president.

The changes had a profound impact on the actions of students. As student body president, Dukes pushed for a more militant program of defying segregation by Miles students. In December 1961, under his guidance, hundreds of Miles students voted to adopt a statement entitled "This We Believe." The remarkable document listed changes that needed to be

implemented in Birmingham, greater access to education and jobs foremost among them. In the wake of the meeting, Miles students formed the Anti-Injustice Committee. The members of the group pledged to oppose racial discrimination and they forged close ties with Shuttlesworth and the civil rights organization he led, the Alabama Christian Movement for Human Rights (ACMHR). Leaders of the committee also met with representatives from the Student Non-Violent Coordinating Committee (SNCC) and the Congress on Racial Equality (CORE) and began to prepare for a boycott of downtown businesses to highlight discrimination. Claiming he was researching a "school project," Dukes obtained figures from the Birmingham Chamber of Commerce that illustrated how profoundly African American customers affected Birmingham's white merchants. To withdraw this patronage through a boycott, Dukes and the other members of the Anti-Injustice Committee reasoned, would mean the merchants might be forced to make real and lasting changes to their businesses. Dukes and the other students hoped that the campaign would convince downtown merchants to dismantle segregation in their stores and restaurants.

As momentum for the boycott grew, Pitts organized meetings in February 1962 between the white business leaders, students, and leaders of the black business community like A. G. Gaston. Gaston in particular worked to negotiate the students' demands with white merchants. Pressured by a potential boycott, some merchants agreed to remove a few of the racist regulations from their establishments. The minor improvements included taking down some Jim Crow signs from water fountains and integrating an elevator in a downtown office building. The white merchants, however, rejected demands for complete integration of their stores and businesses, and negotiations between the different parties broke down.

In March, the Miles College students began their boycott of downtown businesses. The students called their protest a "Selective Buying Campaign" to avoid violating the city's anti-boycott law. The students called for the hiring and promotion of African Americans at the downtown stores and for the hiring of African Americans on the Birmingham police force. They also demanded the integration of downtown restrooms and drinking fountains.

Activists at Miles College forged a broad movement that sunk deep roots in the black community. Shuttlesworth and the ACMHR were key supporters of the boycott. The students and movement operatives distributed fliers and spoke from church pulpits. They employed slogans like "Use a Dime's Worth of Common Sense" and "Wear Your Old Clothes for Freedom." After the boycott began, supporters on sidewalks outside of the businesses, called "educating committees," urged black customers to return goods they had purchased at white-owned stores. The Jefferson County Voters League supported the students, while women from the black community established car pools to transport students to their assignments patrolling downtown businesses. With such strong community support, the boycott cut off 85 to 90 percent of the black business during the crucial Easter Weekend sales period.

Opposition to the boycott coalesced around police commissioner Eugene "Bull" Connor, who had made his political career by his strong support for the white supremacist system in Birmingham. Connor denounced the boycott in early April and then convinced other members of the city commission to support his bid to cut off aid to the county's surplus food program. The money the city withheld would have gone to helping thousands of needy families, most of them African Americans. Connor also stepped up his harassment of the student protestors. Police arrested Dukes and other activists for such common offenses as jaywalking. The city also denied Miles College officials a permit for a "Miles of Dimes Parade" they hoped would help raise money for the school's library. Finally, some downtown merchants like Newberry's and Woolworth's retaliated by firing their black employees. Under unrelenting city pressure, strong resistance by the white merchants, and with support for the boycott fading, the protest collapsed in June.

Despite the setback, Dukes and other student activists were convinced their boycott was justified and they continued to challenge the city's racist policies. In August 1962, two months after the boycott collapsed, Dukes led a contingent from Miles College, future federal

judge U. W. Clemon among them, to the city commission's weekly meeting. The activists presented Connor and other commissioners with a petition signed by more than 800 African Americans asking the city to repeal its segregation ordinances. Predictably, Connor and the other commissioners refused the demand.

The effect of the student boycott, meanwhile, remained profound. In the spring of 1963, the SCLC and ACMHR began a wave of demonstrations that would culminate in the massive street protests of April and May. The core goals of those protests—the desegregation of downtown businesses and restaurants and more job opportunities for African Americans—had been developed by the members of the Anti-Injustice Committee at Miles College a year earlier. Miles College students, and even some faculty and staff, took high-profile roles in the demonstrations that transformed Birmingham and began the process of dismantling official segregation in the city.

Among the more important leaders with strong ties to Miles College who took a lead role in the demonstrations was the Reverend Abraham Lincoln Woods Jr. Woods became an officer in the ACMHR, serving as a second vice president and helping to organize the demonstrations in 1963. He was one of the first ministers arrested and sentenced to labor on the city's "jail farm" for his participation in a round of sit-ins. After the Birmingham demonstrations, during the summer of 1963, Reverend Woods helped organize the "March on Washington." In the decades that followed, Reverend Woods would balance his career in civil rights with his service as a member of the Miles College faculty.

By the end of the 1960s, Miles College had become a nationally known institution. Under Pitts's leadership, SACS accredited the college in 1969. The accreditation represented the culmination of years of hard work, during which officials expanded and upgraded buildings and constructed new dormitories, faculty housing, a science building, a library, and a student union. Enrollment swelled to well over 1,000 students, and the percentage of faculty with doctorates grew to almost 40 percent. Two years before SACS officials made their decision, Pitts convinced John Monro, dean of Harvard College, to resign his position and become director of freshman studies at Miles. Monro had met Pitts in 1963 and had taught at Miles during the following summer. "I've got a special concern for people who start with a disadvantage and may not ever get to college," Monro said when he arrived in Birmingham. The college's budget grew from $340,000 a year to more than $3 million during the 1960s, while the endowment reportedly increased "tenfold."

An important leader who would shape the future of Birmingham in ways that the college's founders had probably never imagined also emerged during the decade. Future Birmingham mayor Richard Arrington Jr. graduated from Miles College in 1955, then returned to teach in the college's science department. In the early 1960s, Arrington left to pursue a doctorate from the University of Oklahoma. Pitts convinced Arrington to return to his alma mater after he received his Ph.D. Arrington served as chair of the Natural Sciences Division and dean, and he helped shepherd the college through accreditation. Arrington later took a position as the head of the Alabama Center for Higher Education, and then set his sights on Birmingham politics. In 1971, he was elected to the Birmingham City Council, becoming one of two African Americans on the body. Eight years later, in 1979, he became Birmingham's first African American mayor. Arrington would credit Pitts with much of his professional and political success. "He was always trying to inspire young people, by his own examples," he said later.

Though journalists concluded that Miles had emerged from the 1960s as "one of the noted black colleges in the country," many challenges remained. By the end of the decade, African American students could attend formerly all-white institutions, even in the South. The national percentage of African American students who attended historically black colleges declined to about 30 percent in the early 1970s, and Miles and other institutions began to suffer a new round of neglect. In particular, Pitts accused federal officials of "ignoring the very institutions that remain in touch with young black Americans."

In 1971, Pitts left Miles College to become president of Paine College, his alma mater, in Augusta, Georgia. The event brought an end to one of the most dynamic eras in Miles College's history. Under his direction, Miles had become a nationally recognized institution, expanding its programs, physical plant, and enrollment, while attracting top faculty and administrators. In this atmosphere, students had thrived, and with their efforts, Birmingham was transformed. Despite new challenges facing historically black educational institutions, the Miles College community could look back on the decade with pride and gaze ahead to the coming years with optimism.

A jubilant Lucius Pitts returns to Birmingham in 1969 after the SACS reaccredited the college. Pitts was greeted by hundreds of students, faculty, administrators, and other supporters of the college.

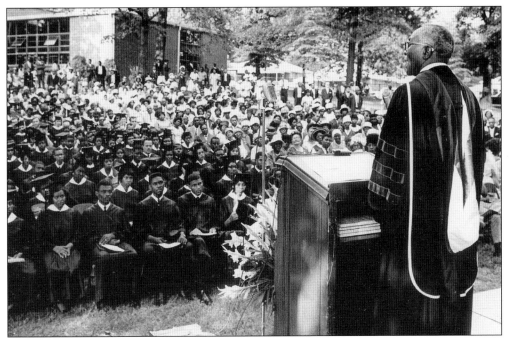

Miles College president Lucius Pitts addresses students, parents and other relatives, faculty, and administration at one of the many commencements he presided over during his tenure.

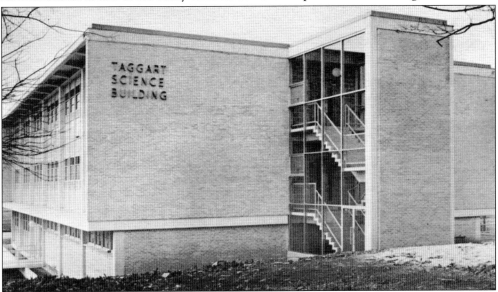

The Taggart Science Building, pictured here in 1966, was dedicated to Mrs. Essie Bolden Taggart, a 1916 graduate of then Miles Memorial College. She graduated from the Chicago Business College in 1920 and became secretary-treasurer of Miles. She was legendary for her ability to find ways to keep students in college despite the sometimes desperate lack of funds. She made the largest single contribution of $50,000 to the building's construction. Ground was broken on Taggart Hall in 1963 and the dedication was delivered by Dr. Wernher von Braun, the father of the United States Space Program. Miles College remodeled Taggart Hall in 2000–2002 to improve its classroom and laboratory facilities.

Here are famed German rocket engineer Wernher von Braun (left) and Pres. L. H. Pitts (right) at the dedication of the Taggart Science Building in 1964.

In 1963, folk singer Joan Baez visited the Miles College campus and delivered "a moving concert." Baez led the students in a stirring rendition of the civil rights anthem *We Shall Overcome*.

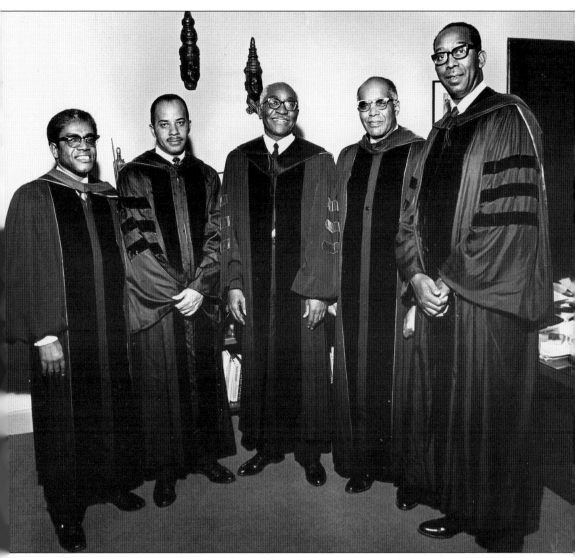

This is a late-1960s photograph of, from left to right, Rev. Richard O. Bass, Dean Richard Arrington, President Pitts, and Bishops E. P. Murcheson and Chester Arthur Kirkendoll.

In February 1956, Autherine Lucy Foster (Miles class of 1952), the daughter of Black Belt sharecroppers, became the first African American to integrate the University of Alabama. In the fall of 1955, after a long three-year court battle, U.S. District Court Judge H. H. Grooms ordered the University of Alabama to admit Lucy as a graduate student in the spring of 1956. On the day of registration, February 3, Lucy arrived on campus in a shiny new Buick sedan, imperiously dressed from head to toe. Hoping to avoid conflict, university officials escorted her to the front of the registration line, ahead of scores of impatient white students. Upset by Lucy's admittance and enraged by her "uppity" demeanor and wardrobe, students revolted. For three excruciating days, protests and demonstrations engulfed the campus. To restore order, the board of trustees suspended Lucy on February 6, explaining that their action was only meant to protect the young woman from further abuse. At a subsequent hearing to determine whether or not the school had actually been in contempt of court for removing her from school, Lucy criticized and lashed out at university officials, suggesting they had conspired with the mob. Judge Grooms ruled that the school had not been in contempt, but ordered officials to reinstate her immediately. Instead of complying with Grooms's latest edict, the trustees expelled Lucy, claiming her previous accusations involving school officials were "false, defamatory, impertinent, and scandalous." Lucy returned to the university in the 1980s and, in 1992, received a master's degree in elementary education. In this photograph, Lucy addresses an audience at the Birmingham Civil Rights Institute during a volunteer appreciation banquet in the mid-1990s.

Actor Greg Morris of *Mission: Impossible* fame receives an honorary degree of letters from President Pitts during the 1969 commencement exercises.

Former Harvard dean John Monro addresses an audience at Brown Hall. In 1967, Monro resigned his position at Harvard and joined Miles College.

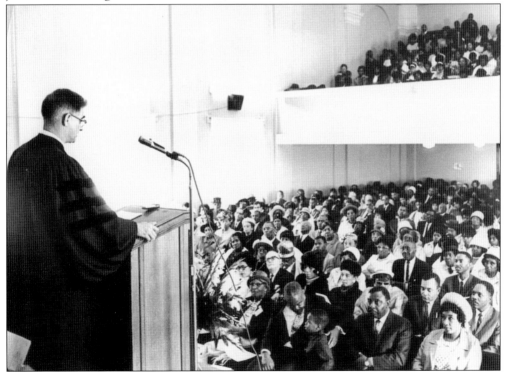

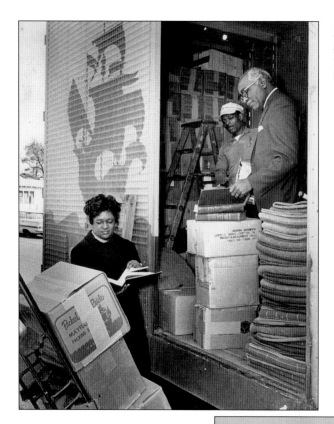

Lucius Pitts examines a shipment of books to build the Miles library collection in the early 1960s.

Lucius Pitts looks on as Metropolitan Opera soprano Mattiwilda Dobbs receives flowers during a reception following her November 1963 concert in Birmingham. The event was sponsored by the Miles College faculty and was held at the city's Municipal Auditorium.

President Pitts accepts a
check from the representative
of the Alpha Wives
during Founders Day.

The Miles College students selected for the Dean's Academic List for 1966 are, from left to right, Barbara Brown, Annie Calhoun, Jacqueline Crenshaw, Gwendolyn Hunter, Henry L. Reese, Adell Smiley, and unidentified. Calhoun, Crenshaw, and Reese would go on to be inducted to *Who's Who in American Colleges and Universities* for 1966.

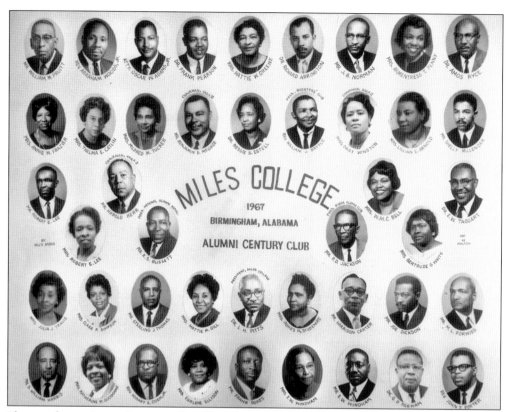

Photos of prominent alumni and staff were compiled in the Alumni Century Club in 1967.

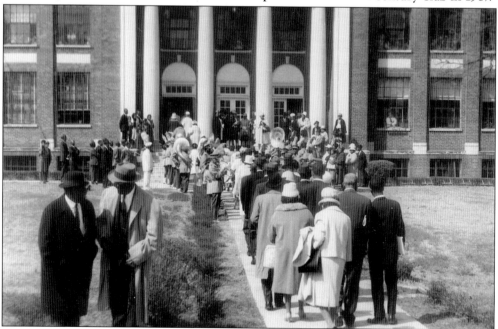

Participants in the CME Church's Missionary March make their way to Brown Hall during the Founders Day ceremony in the 1960s.

The Reverend Abraham Lincoln Woods is one of the most prominent links between Miles College and the civil rights movement. Reverend Woods, a 1962 graduate of Miles who later became one of its longest-serving faculty members, was an officer in the Alabama Christian Movement for Human Rights. He helped lead the street protests in the spring of 1963 and was one of the first ministers arrested during the sit-ins that swept the city. An important lieutenant to Dr. Martin Luther King Jr., Reverend Woods helped organize the March on Washington and became a major force in city politics and civil rights activism. In 1990, he led the effort to integrate Shoal Creek Country Club prior to a PGA event being held there.

President Pitts (right) confers an honorary degree on Dr. W. Clyde Williams (center, wearing glasses) during a commencement ceremony.

Bennett Stewart, a 1936 graduate of Miles College, reached the height of his long career in Chicago-area politics in 1978, when he was elected to the U.S. House of Representatives. A democrat, Stewart had been in Huntsville, Alabama, and had served as an assistant principal at Irondale High School and as a sociology professor at Miles College in 1938, before he moved to Chicago. In the early 1970s, Stewart was elected to the Chicago City Council, where he served for most of the decade. He was defeated when he ran for reelection to Congress in 1980. After his defeat, he took a position as an administrative assistant on the staff of Mayor Jane Byrne from 1981 to 1983.

Lucius Pitts and Bishop
E. P. Murcheson accept a
donation at a Founders Day
ceremony in the early 1960s.

An alumna of Miles College
presents a large check
during a Founders Day
ceremony in the early 1960s
that her organization had
raised for her alma mater.

Lucius Pitts places the crown on Miss Miles College.

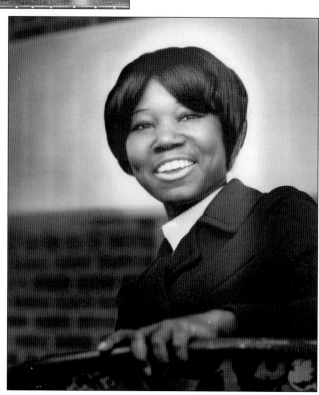

Gwendolyn Williams was chosen Miss Senior in 1967. Here she strikes a pose.

Richard Arrington's family hailed from Sumter County, Alabama, where his father, Richard Sr., earned a modest living sharecropping. In the summer of 1940, shortly before Richard Jr. turned six, the family moved to Fairfield, where the senior Arrington found work with the Tennessee Coal, Iron, and Railroad Company (TCI). Following his graduation from Fairfield Industrial High in 1951, Arrington enrolled at Miles College, pursuing a degree in the natural sciences. After obtaining a Ph.D. in biology from the University of Oklahoma, the young scholar accepted a professorship at Miles in 1966. During his brief tenure at the college, he served as chairman of the Department of Natural Sciences as well as academic dean.

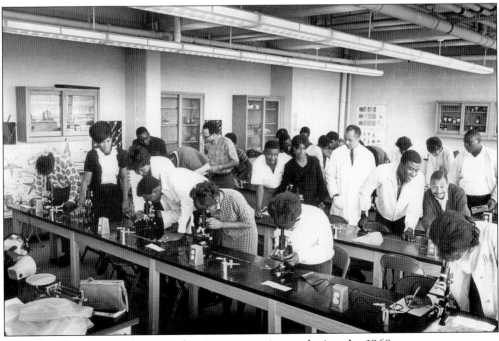

Dr. Richard Arrington directs a class in an experiment during the 1960s.

In 1980, U. W. Clemon, a 1965 graduate of Miles College, became the first African American judge to preside over the U.S. District Court for the Northern District of Alabama. Clemon's parents moved to Fairfield, Alabama, from Mississippi in 1941, two years before his birth. They, like thousands of other Southern families, had been drawn to the city of Birmingham by its wartime industries and promise of a decent wage, seeking to escape a life of poverty and sharecropping. After completing high school, Clemon enrolled at Miles College, where he served as student body vice president and participated in numerous civil rights demonstrations. In 1968, Clemon received a law degree from Columbia University and returned to Birmingham, where he became a partner in the firm of Adams & Clemon. Between 1968 and 1980, Clemon built a reputation as a sterling civil rights attorney, specializing in cases involving job discrimination and school desegregation. He served two terms in the Alabama State Senate, chairing the Rules and Judiciary Committees. From 1976 to 1979, he sat on the executive council of the American Bar Committee. In June 1980, in the middle of his second term as state senator, Clemon was appointed to the federal bench by Pres. Jimmy Carter. Today, Clemon continues to preside over the Northern District of Alabama. He is the recipient of numerous awards and honorary degrees, including the Law and Justice Award from the Southern Christian Leadership Conference and the prestigious C. Francis Stradford Award from the National Bar Association.

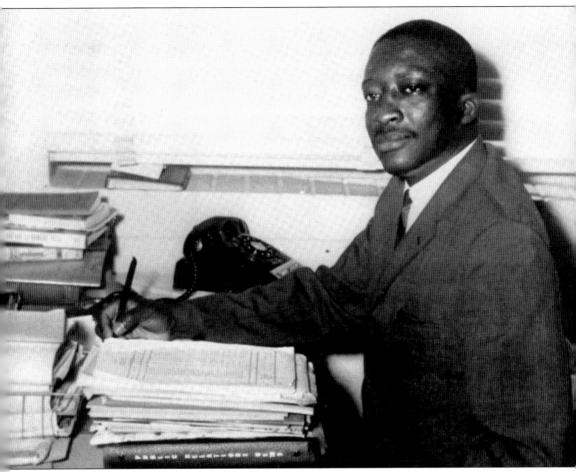

In the early 1960s, Frank Dukes emerged as the leader of the civil rights movement at Miles College. A native of Fairfield, Dukes served in the armed forces during the Korean War and, after his discharge, worked a stint at the General Motors plant in Detroit. In 1959, he returned to his hometown and enrolled at Miles College on the Montgomery G. I. Bill. A superb student, Dukes was elected president of the student government association and regularly made the dean's list. In December 1961, Dukes led 800 students in adopting the statement "This I Believe," vowing "to use every legal nonviolent mean [*sic*] at our disposal to secure for ourselves and our unborn children these God-given rights guaranteed by the Constitution of the United States." In the spring of 1962, Dukes and members of the Anti-Injustice Committee conducted a "Selective Buying Campaign" against certain Birmingham businesses that maintained discriminatory hiring practices and refused to desegregate their restrooms and lunch counters. Although the boycott initially failed to achieve its goals, the "Selective Buying Campaign" served as a blueprint for the more successful demonstrations by the SCLC in 1963.

The graduating class of 1969 posed for this photograph in front of Brown Hall.

Here the entire freshman class of 1965–1966 poses on the lawn in front of the Norton Student Union Building.

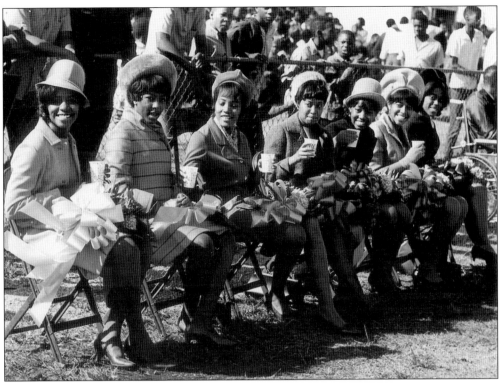

These women enjoy the halftime celebrations at the 1966–1967 homecoming football game.

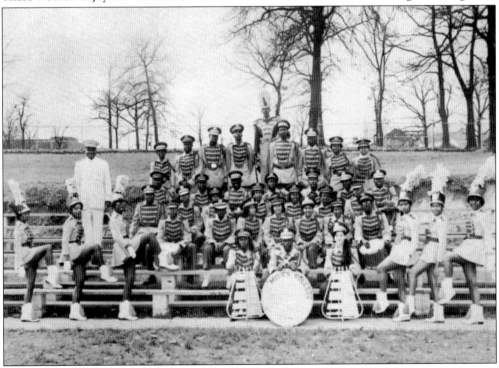

Pictured here are members of the 1962 Miles College marching band.

Lawrence Streeter, a member of the 1964–1965 Miles College basketball team, goes for two against Alabama State.

Members of the 1969–1970 Miles cheerleading squad take a breather during a Golden Bears football game.

Six

CHALLENGES OF THE POST–CIVIL RIGHTS ERA
1971–1989

W. Clyde Williams, who succeeded Lucius Pitts as Miles College president in June 1971, liked to keep a vase full of cotton and a chain atop his desk in Brown Hall to serve as constant reminders of his own personal struggles and the challenges facing his people. "The symbol of the cotton is to indicate how far personally I have come and how far we have come educationally from the cotton field to the head of an institution," Williams told a reporter in 1980. "The chain is a symbol of shackles that have been on us so long. I want to break that shackle. I keep that chain as a reminder to be broken from the past—to loosen us to do exciting and innovating things in the future."

A native of Cordele, Georgia, Williams arrived at Miles College with a wealth of knowledge and experience, having completed divinity degrees from a number of schools, including Howard University, Atlanta University, and the Interdenominational Theological Center (ITC) in Atlanta. Before Fidel Castro's takeover of Cuba in 1959, Williams did missionary work on the island nation, bringing comfort and aid to the sick and indigent. He also worked for the Methodist Student Union in Africa, helping inhabitants "develop their own religious lifestyle and separate it from the overlay of Western colonial Christianity." When tapped to replace Pitts in 1971, Williams held the position of associate general secretary of the Consultation on Church Union in Princeton, New Jersey. He was the unanimous choice of the Miles College board of trustees to assume the presidency.

Williams was admittedly apprehensive about the task before him. The decade of the 1960s had been a time of tremendous growth and achievement for the college, with students serving as the vanguard for the civil rights movement in Birmingham and with President Pitts working to boost the school's academic reputation on a variety of fronts. But the 1970s offered new challenges. During the Jim Crow era, African American students in the state had been barred from such institutions as the University of Alabama and Auburn University. Now, with segregation all but eliminated, blacks suddenly had an assortment of schools to choose from, and, predictably, many began passing over the historically black colleges and universities to attend previously all-white schools. As a result, institutions like Miles, Alabama Agricultural and Mechanical, and Alabama State had to transform themselves in order to

compete with larger schools and their millions of dollars in grants and endowments. Upon assuming his new position, Clyde Williams worried that Miles might not be up to the task.

Despite his doubts, Williams immersed himself in his new role. "I know there is a good future here," he said at the outset of the 1971–1972 school year. "It is not a future of pessimism; it is a future of optimism. It is not a future of failure; it is a future of success. It is not a future of a broken down Miles, but a Miles building up." For the first few years of Williams's tenure, Miles did indeed build up and reshape itself for the coming challenges of the post–civil rights era. In September 1974, responding to the fact that there were only 40 African American attorneys throughout Alabama, Miles opened an evening law school to help ease the deficit. In 1976, thanks to an expansion of federal financial aid programs, the college's enrollment skyrocketed to an all-time high of 1,500 students. A year later, the Kirkendoll Learning Resource Center, a new multi-million dollar library facility, was completed. Williams seemed to have the college on the right path.

Yet, as will sometimes happen, the forces of history conspired to undo much of the president's work and waylay his best intentions. In the late 1970s and early 1980s, the federal government responded to a staggering national recession by curtailing and downsizing some its social programs, including financial aid for college students. More than 80 percent of students at Miles College received some sort of financial aid, and as a result of the government cutbacks, enrollment started to dwindle and the school's financial troubles mounted. During the 1978–1979 academic term, the college's enrollment fell to 1,300. The following year, Miles was forced to cut its football program to save money, and enrollment plummeted again to 1,035. In 1978, the college spent $300,000 more than it took in—a colossal amount for a school the size of Miles—and the president seemed powerless to stop the bleeding. Instead, he pointed to the competitive nature of higher education for the school's shortcomings. "Institutions like Miles have seen the competition for students threaten their enrollments as other types of institutions fight declining enrollments of their own," Williams wrote in the 1980–1981 *Annual Report of the President*.

But Miles's problems continued to mount. In 1982, because of declining enrollment, the college laid off 18 faculty members. Desperate, Williams sought a way to boost the student population. He announced that Miles would begin offering tuition rebates to students who demonstrated "ability and potential for educational success." "If the auto industry can give rebates as an inducement to prospective customers," Williams said in a news release, "then I am sure we can do it to further a person's mind." But the strategy failed. The numbers continued to fall. By 1984, there were only 600 students enrolled at Miles College. Two years later, the numbers had crept down to less than 500. In 1986, Williams resigned his position to run for the office of bishop within the CME Church. That year, the board of trustees elected Leroy Johnson the new president.

Johnson came to Miles with an impressive resume. He had served in the U.S. Navy during World War II and the Korean War, becoming the first African American to receive a line officer's commission under the Reserve Officer Candidate Program. After leaving the navy, Johnson began his long association with the CME Church. In 1952, he was granted a license to preach and, for the next 10 years, served as a pastor in the California Conference of the CME Church. In 1963, Johnson entered the U.S. Army's Chaplain Corps and eventually attained the rank of colonel.

Johnson had his work cut out for him at Miles. The gloomy financial situation and steadily declining enrollment numbers had left the future of the college in doubt. Upon his arrival, Johnson began implementing his so-called Seven Point Program, designed to boost morale, establish a "broad-based recruiting program," improve facilities, raise faculty salaries, and take a positive approach to fund-raising. Despite crafting such an ambitious program, Johnson was thwarted by the financial realities of the period. The college found itself deeper in debt, and he resigned in 1989.

The two decades leading up to Johnson's resignation were in many respects the most turbulent in Miles College's 100-year history, with school leaders struggling to negotiate the often treacherous terrain of the post–civil rights era. In the 1970s, under the leadership of W. Clyde Williams, the student population rose to 1,500, a new state-of-the-art library facility was constructed, the Miles Law School opened, and graduates such as Richard Arrington and U. W. Clemon were helping to transform politics and society not only in Birmingham but across Alabama. Yet such successes could not hope to forestall the challenges of the 1980s, when economics and historical forces threatened to undermine all that had been achieved under the administrations of Pitts and Williams. It would be left to a new president, Albert J. H. Sloan II, to ensure that past struggles had not been rendered in vain and that future victories would be the college's ultimate legacy.

W. Clyde Williams was appointed Miles College president in June 1971. Following an active term in office, Williams resigned his post in 1986 to run for bishop within the CME Church.

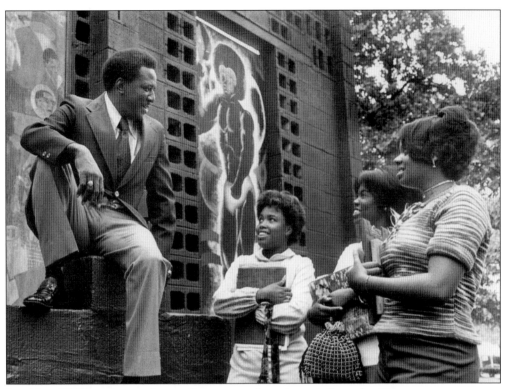

President Williams is seen here talking to students in an informal setting.

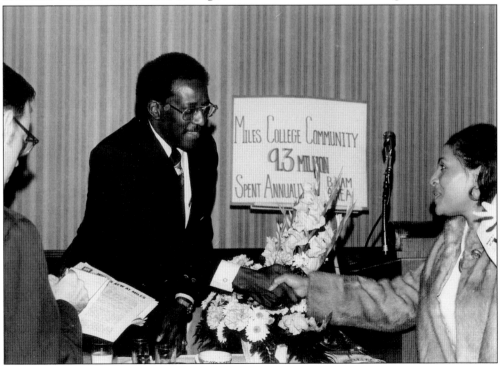

Miles College president Clyde Williams greets a supporter during an event in 1975.

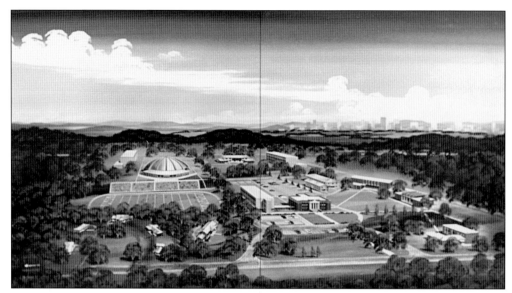

This is an artist's rendering of the 1970s vision of the future campus of Miles College. These visions of the campus have been variously given since the 1920s and graphically show the proposed plans for campus expansion and improvement.

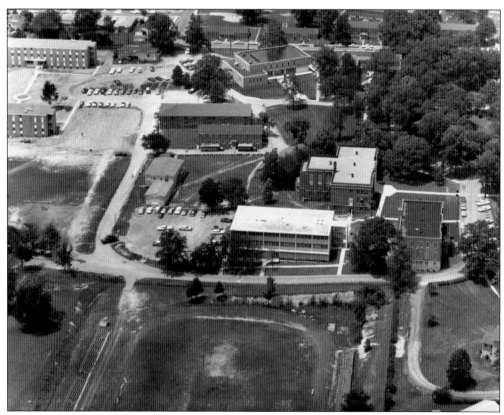

An aerial photographer captured this view of the Miles College campus in the early 1970s.

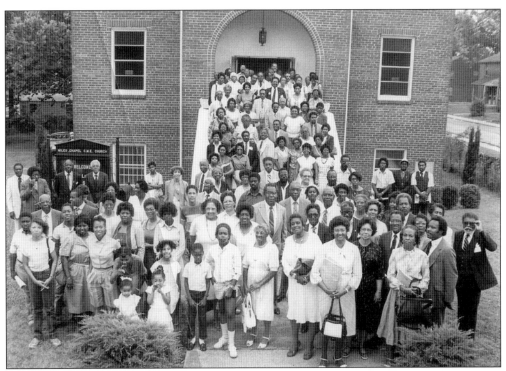

This photograph shows gathering of Miles College and CME church officials in the 1980s.

In June 1971, Jill Jensen of Troy, Ohio, became the first white graduate of Miles College.

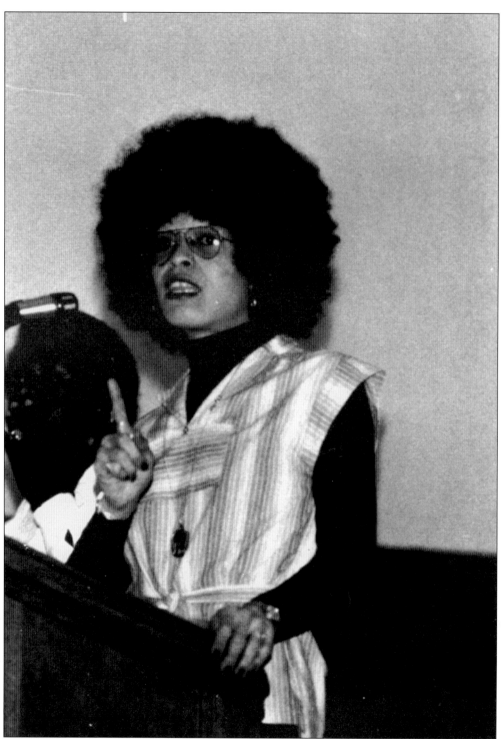

In the spring of 1976, famed activist Angela Davis returned home to Birmingham and spoke to students at Miles College. Angela's mother, Sallye Davis, graduated from Miles in the late 1930s and participated in the Southern Negro Youth Congress.

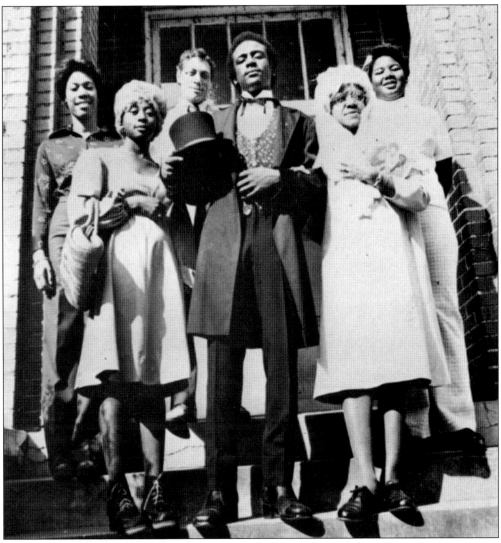

The Miles Mummers, the college's theatre group, performed in a variety of venues both on campus and around the state. During the 1976–1977 school year, the Mummers adapted George Orwell's *Animal Farm* for the stage, performed a montage of speeches by Booker T. Washington and W. E. B. DuBois, and even produced the Langston Hughes one-act play *Certainly Simple*. Pictured from left to right are Patricia Adams, Cynthia Crawford, Dr. Richard L. Lippke (faculty advisor), Johnny L. Clark, Jarushia Thornton, and Linda Smith.

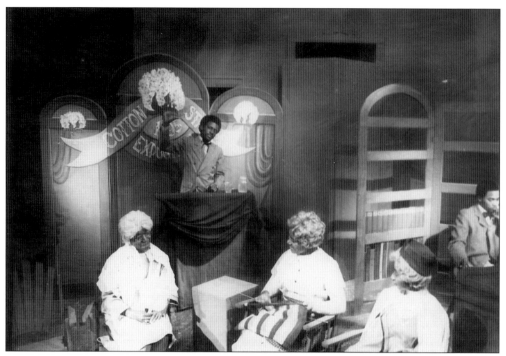

The Miles Mummers perform the *Atlanta Compromise* in 1976.

Here is the Miles College men's basketball team of 1971–1972. Pictured are, from left to right, (first row) McKinley Young, James Knighton, Jerome Dunson, Frederick Cephas, John Thomas, Gary Grooms, and Stanley Jones; (second row) coach Arthur Wilkins, Roosevelt Tarver, Willie Spradley, Arthur Sanders, Robert Davis, Ercell Davis, Donald Woods, and director of athletics T. J. "Papa" Knox.

Pictured here is the Miles College women's basketball team of 1987–1988. They are, from left to right, (first row) Lisa Walden, coach Edward Colvin, and Jackie Ingram; (second row) Wanda Willis, Yolanda Maddox, Karen Carter, and Kim Bryant.

Anthony Colvin played quarterback for the Miles Golden Bears during the 1976 football season.

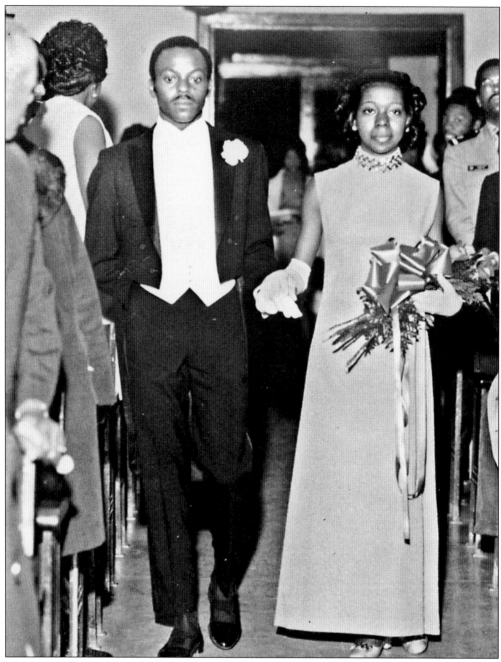

Melvenia Marable was crowned Miss Miles of 1969–1970. Here, she is escorted by the future mayor of Birmingham, Bernard Kincaid.

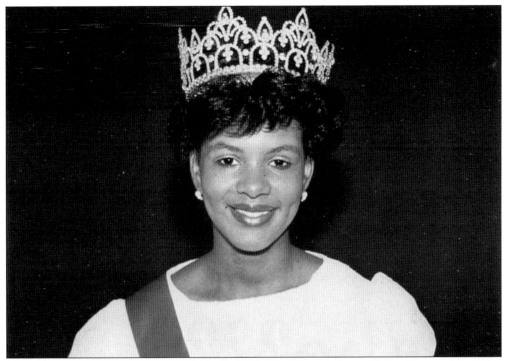

Cynthia M. Smith, Miss Miles of 1987–1988, was a native of Birmingham and a senior majoring in business administration.

Here are members of the Miss Miles entourage of 1970–1971. Mary Sims (right) would be crowned Miss Miles the following year.

These students are enjoying themselves at the 1977 M Day celebrations.

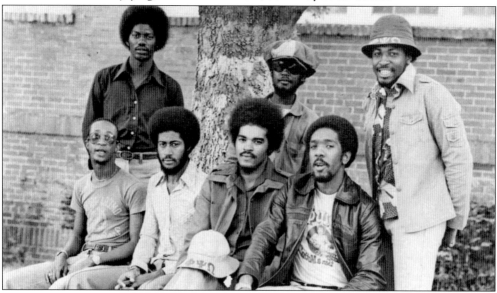

Fraternities and sororities have always been an integral part of campus life at Miles College. Shown here are members of the Omega Psi Phi fraternity in 1977–1978. They are, from left to right, (first row) Wibert Carter, Michael McKissic, Joseph Wiggins, and Gary Wilson; (second row) Herman Williams, Henry Woosenhaum, and Berry Davis.

Diana Knighton, the chief financial officer (left) is pictured with a Tuskegee Airman and the former mayor of Birmingham, Dr. Richard Arrington Jr. (right)

When Leroy Johnson assumed the presidency of Miles in 1986, he arrived with a "Seven Point Program" designed to boost morale, generate additional funding, and aggressively recruit students. Yet, despite his best efforts, Johnson's goals were unrealized due to financial difficulties..

Leroy Johnson had spent a better part of his adult life in military service. After high school, he enlisted in the U.S. Navy, serving during the World War II and Korean War eras. During his stint in the navy, Johnson became the first African American to receive a line officer's commission under the Reserve Officer Candidate Program. In July 1963, he entered the U.S. Army Chaplain Corps, eventually attaining the rank of colonel. Johnson (left) was officially inaugurated as Miles College president in October 1987.

Seven

THE SLOAN YEARS
1989–Present

In 1989, after serving the college for 18 years in various capacities, including dean of chapel, dean of students, director of public relations, and director of the Miles College/Jefferson County Emergency School Aid Act Program, Albert John Hicks Sloan II was asked to "hold" the presidency of Miles College by the board of trustees.

Given the tumultuous condition of the college at the time, it was the board's intent, under the direction of chairman Bishop Richard O. Bass Sr., to fill the vacancy left by president Leroy Johnson expeditiously if only temporarily. Thus, they requested Sloan "hold" the office. However, as one of Sloan's closest advisors would intimate, "If they let you hold it, they will not get it back."

Much to the college's benefit, this intimation held true, leading to one of the most successful presidential tenures in Miles College history. On March 28, 1992, after serving two and one-half years as interim president, Albert J. H. Sloan II was inaugurated as the president of Miles College. However, success would not come easy, and for many within the Birmingham community, it was not a foregone conclusion. In fact, many mocked the new administration, holding that instead of being appointed to oversee resurgence, Sloan was appointed to preside over the funeral of the college.

Indeed, the early days of the Sloan administration were dismal. Enrollment had plummeted to 438, the physical plant was inadequate and deteriorating, the endowment was below $650,000 and shrinking, tenured faculty positions were being eliminated, morale among faculty, students, and alumni was low, and the college owed nearly $4 million to the federal government. Adding insult to injury, the college was on probation with the Southern Association of Colleges and Schools (SACS) since 1986 for cash flow problems. In December 1989, Miles was dropped from membership in SACS. This permanent loss of accreditation would have signaled certain death for Miles, for without accreditation, credit for courses taken at Miles would not transfer to other schools, and the college would be ineligible to receive federal financial aid for its students—this would have closed the doors of the college forever.

Unfettered by the numerous and formidable challenges, Sloan began methodically and aggressively chipping away at the mountain of troubles before him. Sloan's first priority was to bring the college into good accreditation standing with SACS. Again, this would not be easy, as the college faced the December 1989 revocation decision.

President Sloan initiated cost-cutting measures, including asking faculty and staff to make contributions to the college, tightening accounting practices, raising money within the

community, and collecting on delinquent student accounts. He also aggressively tightened financing by borrowing $500,000 from the endowment and placing it, with restrictions, in the general operating fund, He was now able to initiate his plans to regain financial solvency.

On June 19, 1990, a team of college officials reargued their case for accreditation before an adjudicating committee in Atlanta, Georgia. On the next day, June 20, SACS restored the college's accreditation, breathing new life and hope into the institution, which had been at the proverbial "doorstep of death." Subsequently, SACS also reaffirmed Miles's accreditation during the standard review process in 1993 for 10 years. "I'd love to say my skill in administration did it, but I have to say it was the Lord that has brought us here. I am a person of faith," Sloan is quick to assert.

Having successfully overcome accreditation challenges, the Sloan administration continued to focus upon fiscal stability and accountability. Through arduous negotiations with the United States Department of Education, a $4 million federal debt owed for improper loans made to law school students (as the school was not accredited by the American Bar Association) was reduced to $1.7 million. Later, the $1.7 million was further reduced to $442,000, which was paid by the college through bank loans.

Having re-established financial stability and some measure of credibility with the federal government through the liquidation of outstanding loans and the reaffirmation of accreditation, the Sloan administration stood on the threshold of a new era for the college.

After overcoming the challenges of the late 1980s, it appeared that the Sloan administration would never look back. A surge of progress during the 1990s positioned the college for success into the next century. While cohort institutions nationwide experienced downsizing and some closed their doors, Miles was fortunate and blessed to establish a new paradigm. In 2003, SACS reaffirmed the accreditation of Miles College to grant bachelor's degrees in 22 majors.

From 1989 to 2005, student enrollment virtually quadrupled, growing from 438 to more than 1,700. At the beginning of Sloan's tenure, the college was categorized as a commuter school, housing less than 25 percent of its students on campus. By 2005, with the opening of the 204-bed men's residence hall, the 148-bed Richard O. Bass Sr. women's residence hall, and the acquisition of the 40-bed Monte Sano Apartment complex, and pre-existing campus housing, more than 750 students, or nearly 50 percent, were campus residents. This shift in the on-campus housing population would change Miles forever, putting the college in line with mainstream institutions across the nation. A consequence of the increased residential population was found in unprecedented student participation in such organizations as the college band, the "Purple Marching Machine," and the college choir, boasting memberships of 200 and 112 respectively during the 2004 academic year.

So entertaining was the Purple Marching Machine that it was one of 12 bands nationwide invited to the 2002 Macy's Day Parade. Not to be outdone, the college choir was featured during the January 1999 inauguration of Alabama governor Donald Siegelman in Montgomery, Alabama.

During the same 1989–2005 period, the college endowment grew from $650,000 to more than $11 million, which represents the largest endowment in college history. Factors contributing to exponential endowment growth included sound financial management, the awarding of an Endowment Challenge Grant through the U.S. Department of Education and a board of trustees policy implemented during the early stages of the Sloan administration. This policy mandated that one-half of any operating year-end budget surplus be restricted for the endowment. The endowment growth and yield were substantial factors in the college receiving optimal credit ratings by rating agencies such as Standard & Poor's, Moody, and others in anticipation of borrowing needed funds for construction and expansion. Corollary to endowment growth, the college's operating budget grew from $4 million to more than $27 million, with surpluses each year.

To assure sustained financial growth and stability, in 1999 the college embarked upon the largest and most ambitious capital campaign in its nearly 100-year history, the "Determining Our Destiny" campaign. In spite of the fact that the college had attempted eight previous

campaigns over the past nine decades, with none meeting expectations, the Miles team was determined to challenge the status quo and prove its viability and worth to the Birmingham constituencies.

Although a professionally commissioned feasibility study concluded that the college would only be able to raise $1.5 million within a three-year period, the board of trustees approved a $10 million, five-year campaign. Much to the surprise of the Birmingham community, the $10 million goal was met and exceeded nearly three years ahead of schedule. In the end, the college realized $12 million in revenue.

The success of the Destiny campaign was as much of a financial windfall as it was an effective public relations campaign. With lead gifts from such corporations as Alabama Power, AmSouth Bank, SouthTrust Bank, Energen, and HealthSouth Corporation, the Destiny campaign was a clarion call for the Birmingham corporate community to again embrace the vision of Miles through significant financial support.

While the corporate community, alumni, and friends of the college were ecstatic about the success of the Destiny campaign, there remained somewhat of a wait-and-see attitude among donors. To the community, the "proof would be in the pudding," as they looked to Miles for tangible signs of good stewardship and accountability following the Destiny Campaign. As 72 percent of the campaign goal was designated for new buildings, renovations, and campus improvement, all eyes were on Miles to see if these goals would be realized. The community did not have to wait long. On the heels of the Destiny campaign, the college embarked upon the most expansive building campaign in college history.

At the center of the building campaign was the confluence of past achievements and future hopes with the renovation of historic Brown Hall and the construction of the new Frank Pearson Academic Building. The renovation of Brown Hall, the second oldest building on campus, was facilitated through a $2 million grant from the United States Department of the Interior, matched with $2 million from college coffers. With $4 million in improvements, the building was totally gutted and renovated to meet the demands of a new century.

At their semi-annual meeting on March 9, 2005, the board of trustees voted unanimously to name the new $6 million academic building in honor of Mr. Frank Pearson, who dedicated more than 40 years of his life to Miles College. The Pearson Academic Building is a three-story, state-of-the-art facility housing the academic dean's office as well as a 400-seat auditorium, classrooms, and faculty offices.

In total, the Sloan administration distinguished itself as being responsible for the construction and major renovation of 10 buildings on campus as well as for doubling the physical grounds of the college to more than 54 acres. Construction and/or renovation projects included: Ramsay Hall (1996), Knox-Windom Gymnasium (1996), Bass Hall Dormitory (1999), Albert J. H. Sloan Alumni Stadium (2000), Plant Maintenance Building rebuilt and annex constructed (2002), Monte Sano Apartment Complex acquired (2002), Christian Industrial Building acquired and renovated (2002), Frank Pearson Academic Building (2005), a new men's dormitory (2005), and Brown Hall renovated (2004).

Noting the vast building initiatives, Sloan shared, "The current administration stands on the shoulders of those who have paved the way for the successes which the college now enjoys." While every administration has had indelible influences on the life of the college, the administration of Dr. Albert J. H. Sloan II witnessed some of the more glorious days within the life of dear old Miles. Indeed, under President Sloan's careful watch, the mission of the educational sanctuary was preserved and her walls strengthened to meet the challenges of a new century.

Albert John Hicks Sloan II was inaugurated on March 28, 1992. He received a baccalaureate degree from Albany State College, a master of divinity degree from the Interdenominational Theological Center, and his doctorate of jurisprudence from the Miles Law School. He also received a doctorate of divinity from Faith Grant College in Birmingham, Alabama, and a doctorate of laws degree from Texas College in Tyler, Texas. Dr. Sloan came to Miles College in 1971. During his 34-year tenure, he successively became professor of religion and philosophy, director of public relations, dean of chapel, and dean of students. Since Dr. Sloan became president, the student enrollment has increased from 438 to 1,700 students, the academic curriculum has been redefined, the budget has increased from $4 million to $27 million, the revenues have increased by 92 percent, and the endowment has increased from $650,000 to $11 million. He launched a $10 million capital campaign, the largest in Miles College history, which raised $12 million. He built several new structures, including a women's dormitory and the Albert J. H. Sloan Alumni Athletic Stadium. He has also renovated existing buildings across the campus. Miles has now concluded a $21 million capital improvement and building program.

Pres. Albert J. H. Sloan Jr., Bishop Othal H. Lakey, Bishop Lawrence L. Reddick III, and Dr. George T. French Jr. pose before the new Miles campus entrance, completed in January 2004.

Bishop Lawrence L. Reddick III, chairman of the Miles College Board of Trustees, gives an address in 2003.

Rev. Jessie Jackson speaks at the Miles College Founders Day in Brown Hall. He ran for president in 1988. Miles often hosts nationally prominent legislators, social activists, and other persons prominent in diverse fields to speak to our students.

The Honorable Artur Davis, U.S. Congressman, visits Miles in August 2003 and is hosted by the political science club. Student government association president Nick Trotta (right) presents a gift to Congressman Davis.

Fairfield mayor Larry Langford is the guest speaker for Miles at a ceremony at the First Baptist Church of Fairfield.

In 1999, Bernard Kincaid became the second African American to be elected mayor of the city of Birmingham. Kincaid, a native of Pratt City, was born in 1945, the son of a coal miner. Following high school and a four-year turn in the Air Force, he enrolled at Miles College, where he excelled academically and served as president of the student government association. After earning graduate degrees from the University of Miami–Ohio and the University of Alabama, Dr. Kincaid accepted a professorship at University of Alabama–Birmingham. He was later promoted to the position of assistant to the dean for cultural diversity and minority affairs in the School of Health Related Professions. After serving for a number of years on the Birmingham City Council, Kincaid was elected mayor.

Fairfield mayor Larry Langford and representative Earl Hilliard are pictured here during a ceremony in President Sloan's office. Langford and Hilliard are longtime supporters of Miles College.

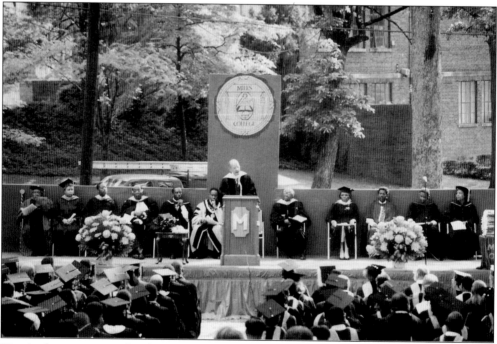

Birmingham mayor Richard E. Arrington Jr. gave the keynote address at an outdoor Miles commencement on May 7, 1995. He spoke of building a strong personal foundation that would help us to meet the challenges of life.

Dr. Ricky Lee (left), Mrs. Emma Sloan, and President Sloan (right), are pictured at a CME function.

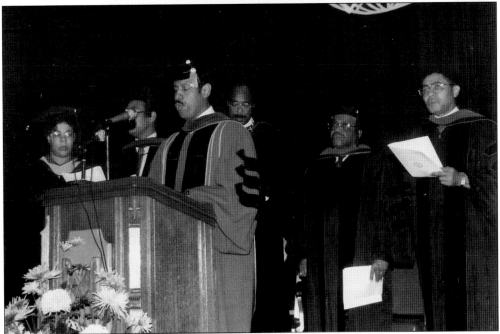

Chaplain Sloan gives the benediction at a commencement ceremony. President Johnson is in the background (center) while Bishop Richard O. Bass, chair of the Board of Trustees (right) and Bishop Gilmore (far right) look on.

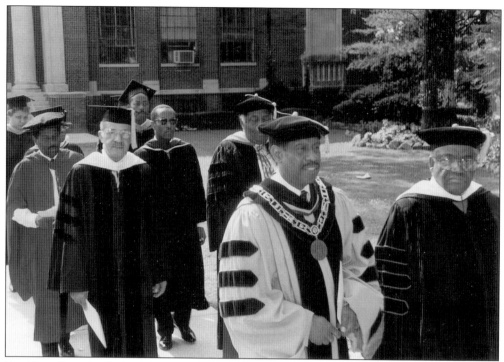

President Sloan leads the cabinet party and guests at a Founders Day ceremony at Brown Hall. On the left is Diana Knighton, business manager; Mayor Arrington is fourth from left, holding a program; President Sloan is in the foreground; and Bishop Bass is on the right.

Band director Arthur Means and President Sloan receive a generous donation from a Miles supporter, Mrs. Grant, on behalf of her alumni group.

President Sloan (center), academic dean Hattie G. Lamar (far right), and Prof. Digambar Mishra (far left) pose with the representatives of the United Nations Association, U.S.A. State president Mrs. Dorothy Baker stands between Professor Mishra and President Sloan, and National UNA-USA president Ambassador Alvin Adams is between Lamar and President Sloan.

Dean of student affairs Dr. Carolyn Ray addresses Miles students.

Under the leadership of academic dean Dr. Hattie Lamar (right), Miles has strengthened its commitment to the liberal arts and cultural enrichment, sustaining its role as a sanctuary for learning. In this photograph, she stands with the Miles College Choir under the direction of Bernard Williams (left).

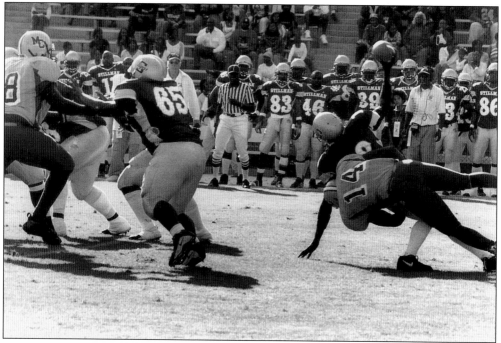

Here are the Golden Bears in action at the Miles-Stillman game in 2003.

Learning opportunities for students at Miles College include study abroad. In Africa on a grant from the Fulbright Program of the U.S. Department of State, Sallie Ransom (right), a senior in social work researching caregiver stresses in the age of AIDS, is welcomed by chief nursing sister Hilda Lungu (left) of the University of Malawi, that nation's preeminent educational institution. Dr. Beverly Hawk, Dr. Digambar Mishra, and Mrs. Sylvia Weed of the Miles faculty have served overseas as Fulbright scholars, and Dr. Connie Pedoto has been selected to serve as a Fulbright scholar specialist in 2006. Campus initiatives in global studies have also benefitted from the international travel and experience of the diverse faculty.

Young scholars celebrate
Founders Day in 2004.

President Sloan and First Lady Emma Sloan join in the festivities for homecoming in 1997. Pictured from left to right are President Sloan, Shevia Smith, Loraine Brown (Miss Miles for 1997–1998), Jennifer Littlepage, and Mrs. Emma Sloan.

Dedicated faculty convene to learn from Miles College specialists in the Counseling, Advising, and Testing Program; the Freshman Studies Program; and Student Support Services about initiatives that are designed to meet the needs of students from a variety of backgrounds. Through these innovative programs, Miles College is able to sustain the vision of its founders and fulfill its responsibilities to each student it enrolls.

Pictured here is the Miles College commencement ceremony at Boutwell Auditorium in Birmingham, Alabama, May 2002.

Director Dr. Geraldine Bell is pictured here with employees of the Miles College Kirkendoll Learning Resource Center (LRC). From left to right are Kim Gordon, Shirley Epps, Dr. Bell, Gladys Madison, and Patrice Tutt. The LRC is home to the Miles College Archives of historic photographs and memorabilia contributed by alumni and friends. The librarians of the LRC worked diligently with the historians of the Miles Centennial History Committee to provide the sources and many photographs presented in this book.

The Miles College Board of Trustees meets in the board room of the LRC in 2005.

Miles College

Board of Trustees Roster

Bishop Lawrence L. Reddick III, Presiding Bishop and Chair of the Board of Trustees

AFTERWORD
"The Vision is Still Valid"

The words quoted above formed the theme of an exceptional message delivered by Bishop John Hurst Adams to a crowd of about 450 persons at a Centennial Celebration banquet for Miles College in March 2005. The Christian Methodist Episcopal Church leaders who envisioned the ministry of Miles College saw an opportunity to bring meaningful academic challenges to men and women whose potentials were often thwarted by the prejudices of their day. It would be erroneous to suggest that those prejudices are gone or are so invalid that the purposes for a college at the beginning of the 20th century no longer exist in these opening years of the 21st century.

As Miles College continues to prepare civic leaders for cities and hamlets, as it challenges brilliant minds to find sharper refinement in the nation's graduate schools, and as it takes "diamonds in the rough" and helps them lose their dross and bring out their shine, it proves to an academic world of large and small colleges and universities that it, too, has an important niche in promoting the educational development that breaks the cycles of ignorance and oppression. The persevering commitments and sacrifices of the administration, faculty, and staff suggest that the cooperative venture of church and academe to help people reach their greatest educational potentials is still important on the Miles College campus in the 21st century. We are determined that Miles College will continue to exist and thrive as long as that "vision is still valid."

—Bishop Lawrence L. Reddick III
Chair, Board of Trustees

CENTENNIAL HISTORY COMMITTEE

WORKING COMMITTEE ON THE HISTORY OF MILES COLLEGE

Dr. Digambar Mishra, Chair
Dr. George T. French Jr., Author
Dr. Beverly Hawk, Editor
Dr. John Morgan, Author and Editor
Dr. Gary Sprayberry, Author
Dr. Robert Woodrum, Author

Advisors

Bishop Lawrence L. Reddick III
Bishop Othal Hawthorne Lakey
Dr. Albert J. H. Sloan II
Dr. Richard E. Arrington Jr.
Dr. Geraldine Bell
Dr. Robert Cassanello
Mrs. Mattie Mashaw Jackson
Dr. Hattie Lamar
Rev. Abraham Lincoln Woods Jr.

SELECT BIBLIOGRAPHY

Alabama Voice.

Bell, William A. *Miles College—Historical*. Unpublished manuscript, 1955.

Birmingham Age Herald.

Birmingham Civil Rights Institute Archives, various papers.

Birmingham News.

Birmingham Post and Herald.

Birmingham Public Library Archives, various papers.

Birmingham Weekly Review.

Birmingham World.

Cassanello, Robert. *A History of Miles College, 1902–1969*. Unpublished manuscript, 2001.

Dixon, J. C., et al. *Miles College: A Study of a College for Negroes in Relationship to the Industrial and Community Interests of the Area in which it is Located*. Unpublished manuscript, 1943.

Dodd, Don. "Birmingham Aviation: From Fairgrounds Air Shows to the Southern Museum of Flight." *Alabama Review* 57 (January 2004): 44-61.

Eskew, Glenn T. *But for Birmingham: The Local and National Movements in the Civil Rights Struggle*. Chapel Hill: UNC Press, 1997.

Franklin, Jimmy Lewis. *Back to Birmingham: Richard Arrington Jr. and His Times*. Tuscaloosa: U of Alabama Press, 1989.

Kansas Plain Dealer.

Kelly, Robin D. G. *Hammer and Hoe: Alabama Communists during the Great Depression*. Chapel Hill: UNC Press, 1990.

Lakey, Othal. *The History of the CME Church*. Memphis: CME Publishing House, 1985.

McWhorter, Diane. *Carry Me Home: Birmingham, Alabama, the Climactic Battle of the Civil Rights Revolution*. New York: Touchstone, 2001.

Miles College Archives.

The New York Times.

Phillips, C. H. *The History of the Colored Methodist Episcopal Church in America*. 2nd ed. Jackson, TN: CME Publishing House, 1900.

The Pittsburgh Courier.

Rogers, William W., Robert D. Ward, Leah R. Atkins, and Wayne Flynt. *Alabama: The History of a Deep South State*. Tuscaloosa: U of Alabama Press, 1994.

Thornton, J. Mills. *Dividing Lines: Municipal Politics and the Struggle for Civil Rights in Montgomery, Birmingham, and Selma*. Tuscaloosa: U of Alabama Press, 2002.

University of Alabama at Birmingham Archives, various papers.

Woods, Abraham Lincoln. "Biographical Sketch."

www.arcadiapublishing.com

Discover books about the town where you grew up, the cities where your friends and families live, the town where your parents met, or even that retirement spot you've been dreaming about. Our Web site provides history lovers with exclusive deals, advanced notification about new titles, e-mail alerts of author events, and much more.

MADE IN THE USA

Arcadia Publishing, the leading local history publisher in the United States, is committed to making history accessible and meaningful through publishing books that celebrate and preserve the heritage of America's people and places. Consistent with our mission to preserve history on a local level, this book was printed in South Carolina on American-made paper and manufactured entirely in the United States.

This book carries the accredited Forest Stewardship Council (FSC) label and is printed on 100 percent FSC-certified paper. Products carrying the FSC label are independently certified to assure consumers that they come from forests that are managed to meet the social, economic, and ecological needs of present and future generations.

FSC
Mixed Sources
Product group from well-managed forests and other controlled sources

Cert no. SW-COC-001530
www.fsc.org
© 1996 Forest Stewardship Council

Find Your Place in History.